American Realist

Stevan Dohanos

American Realist

Stevan Dohanos

 North Light 37 Franklin Street
Westport, Connecticut 06880

Published by NORTH LIGHT PUBLISHERS, a division of
FLETCHER ART SERVICES, INC., 37 Franklin Street,
Westport, Conn. 06880

Distributed to the trade by Van Nostrand Reinhold Company,
a division of Litton Educational Publishing, Inc., 135 West
50th Street, New York, N.Y. 10020

Manufactured in U.S.A.
First Printing 1980

Library of Congress Cataloging in Publication Data

Dohanos, Stevan, 1907–
 American realist.

 1. Dohanos, Steven, 1907– 2. Artists—United
States—Biography. I. Title.
N6537.D58A2 1980 760'.092'4 [B] 80-13884
ISBN 0-89134-027-0

Edited by Fritz Henning
Designed by Steven Dohanos
Composed in Goudy by Stet-Shields Inc.
Printed by Federated Lithographers
Bound by A. Horowitz and Son

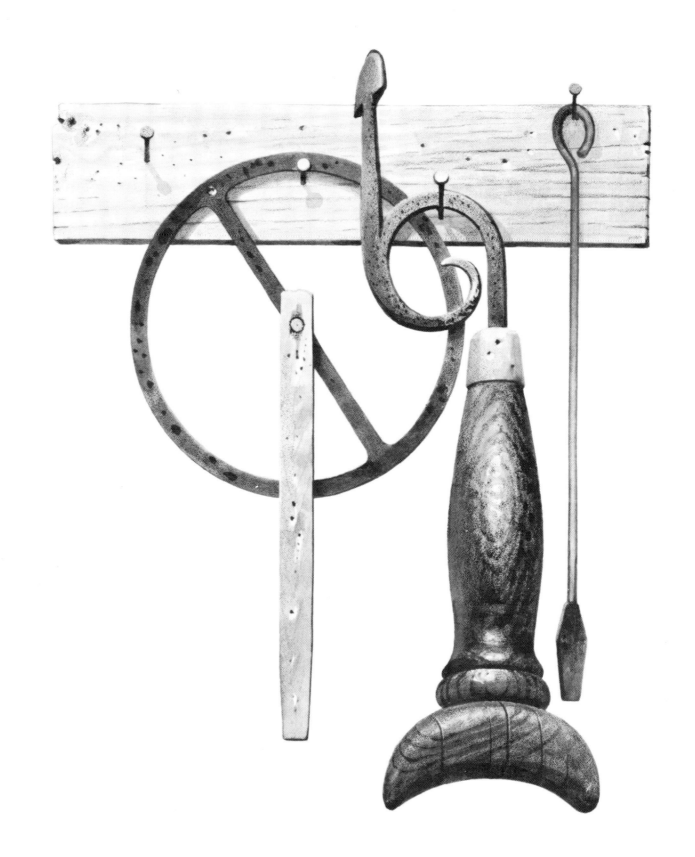

List of Illustrations

Contents

The White Storks of Europe

European White Storks are large birds, standing 40 or more inches tall when fully grown. Their migratory habits take them on long flights to North Africa for the winter months, but invariably they return to nest in the area in which they were born. Their favorite lodging is on roofs and chimney tops of houses. Since the middle ages a legend has persisted that a nesting stork on the roof is an omen of luck and good fortune. I feel sure the roofs of my parents' homes were hosts to a number of stork generations.

My parents were born and raised in a rural area of Hungary. Although they did not know each other and lived in different villages, they grew up in similar surroundings. Each lived in a thatch-roofed farmhouse, clustered with similar houses along a village street. The tillable land and pastures were spread out in neighboring areas. Every morning the animals were led out to pasture and the oxen to work. At the end of the day all returned to the village. The back half of the farm dwellings served as barns and each yard was contained within a wall. The

In 1967 I had the pleasure of visiting Hungary, my parents' homeland. While there I encountered this pair of nesting young White Storks, not fully grown. It was with a mood of genuine pleasure that I set up my traveling easel and recorded this scene. The painting, in opaque watercolor, is 20 × 24 inches.

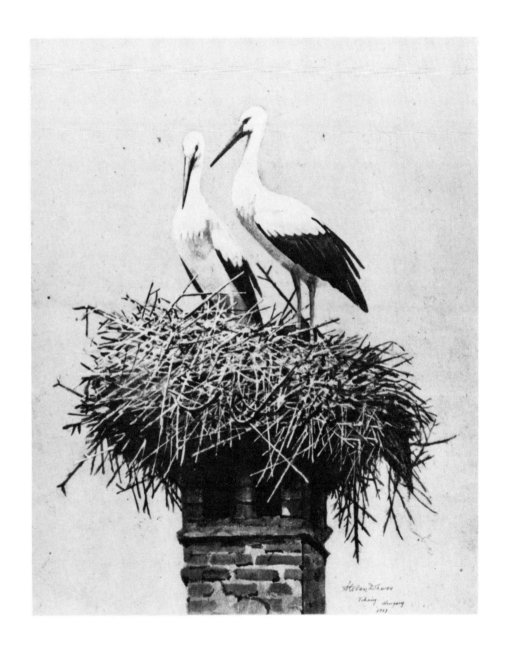

most highly prized feature of any farmyard was a chimney or roof top nest of the White Storks.

This is where my parents, Elizabeth and Andras, lived and labored in their early years. They did not know that their future lives would be as husband and wife in a land called America.

I elect the Great White Stork of Europe as my symbolic bird of good luck. Now it is the American Bald Eagle that represents everything I respect and revere about my native land, the United States of America. Somewhere between the White Stork of Europe and the American Bald Eagle is the story of my life.

It is to my parents, who at ages 16 and 17 immigrated to this country, that I dedicate this book. If they had not chosen to come to America, this land of opportunity, I could well have been born a peasant in Hungary. By this circumstance I have had the opportunity to become an artist and a citizen of the United States.

At the turn of the century, immigrants such as my

parents were assured of employment on their arrival. Labor recruiters toured Europe and signed up needed hands for the growing factories in the New World. Ship after ship was filled with these poor, trusting, adventurous souls and brought them to our eastern shores. Upon arrival my father was sent to work in a steel mill in Lorain, Ohio. Also settling there was Elizabeth with her mother's family. Elizabeth and Andras met and were married in Lorain in 1903. They raised a large family. I was the third to arrive on the scene. The year was 1907.

We children grew up in a millworker's house similar to all others that spread outward from the great steel mill. The immigrant workers soon established churches and social centers where they were able to maintain their homeland customs. We were all doubly enriched enjoying the mixture of both Hungarian and American cultures. We studied both languages, Hungarian in the church school and English in the public schools. As soon as we were old enough—in my case before I was twelve—we were expected to work after school hours and contribute

our earnings to the family budget. Like many young Americans, I earned my first pennies selling newspapers. At an early age I began working after school in a grocery store. In the summertime jobs were available on the nearby farms. At sixteen my first full time job was driving a delivery truck for a flower shop. A job in the steel mill followed. Many of these impressions and experiences from my early years have surfaced as subject matter and themes for paintings.

What little social and cultural activity we enjoyed was centered around our church. On one notable occasion a dramatic coach came to town to direct and produce Hungarian folk plays for our church. This was my first experience in the world of creativity and self expression. The bright world of the imagination opened its doors to me and from that day on, I knew it would be my world, too.

At one stage of my employment in the steel mill, I changed to an office job. At my desk I chanced upon art calendars arriving in the mail. Some of these I copied in

colored crayons and sold to my fellow office workers for two or three dollars. The subjects usually were scenic landscapes, but at some point I discovered magazine art. A crayon copy of one of Norman Rockwell's early Saturday Evening Post covers became my "best seller." Top price three dollars. It was a scene of a tramp roasting a hot dog over a fire built in a tin can. A hungry dog, between the man's legs, watched the cooking with anticipation. I did not know then that years later I would produce art for the famous Saturday Evening Post and Rockwell would become a personal friend.

My first instruction in art was a two year home study course. About this time I learned about the Cleveland Art School and decided to attend evening classes. After my first term I was awarded a scholarship, allowing me to go on to second and third year courses. This was the help and encouragement I needed. Soon thereafter I was able to get a job as an art apprentice in a Cleveland commercial art studio.

With my background of the work-a-day world, it was natural I should expect my art efforts to result in wages.

A salaried art job was a concrete achievement that could be translated into time spent and dollars received. The ensuing years of employment were dedicated to giving my employers their money's worth.

After three or four years of working as a part of the Cleveland art market I became acquainted with a few Fine Art painters. It was a revelation to learn their work was not related to industry. They painted as they pleased and made their living through sales of pictures, working as art instructors, or as part-time workers in other fields.

Commercial art was considered a thing apart by the fine art world. In later years, however, this gap has narrowed. Today fine art artists are used more and more by industry. And the commercial artist's efforts along with that of some photographers are slowly finding acceptance on the museum level. Magazine illustration in particular is coming into its own and is looked upon as an important pictorial history of the American scene.

It is my hope that I have added my small share to this cultural repository.

the common object

As an artist I consider myself a spiritual child of the "Ash Can School" of painting. By coincidence, it was about the time I was born this noted era of art roared onto the American scene. I was just nine months old in February 1908 when Robert Henri, John Sloan, William Glackens and other members of The Eight held the exhibition that turned the tide against the established academic pretty paintings of the day. The Eight and their disciples painted realism. They painted things as they saw them, as they felt about them, as they were. The humble, the homely and the drab became subjects for gallery paintings. At first these works of the commonplace things and places were considered shocking and ridiculed as ugly, but the truth and quality of the art could not be long denied.

As an artist I have always gloried in finding beauty in the ordinary things of life. No doubt much of this response is rooted in my early experiences. The area I grew up in made a lasting impression on me. A steel mill town in western Ohio is not noted for aesthetic elegance. On reflection I realize my family and neighbors were not conscious of style, fashion or beauty as such. For many, maybe most, aesthetic awareness never occurred. For me it came slowly, step by step, year by year. Eventually it came and I knew I wanted to express in a lasting visual form the simple beauty of the ordinary things that mean so much to me.

In painting, the artists who inspired me most are Charles Burchfield, Grant Wood and Edward Hopper. These stalwarts of American realism were, and are, my guide and shining light. A common object in such artistic hands can be a monumental visual experience.

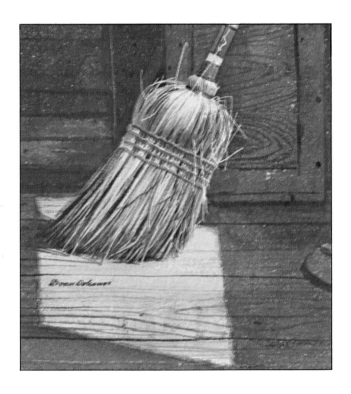

The design and beauty inherent in common objects is the key to my point of view as an artist. I painted this careworn broom in 1937. It especially represents my personal, selective approach on not how to paint, but instead, what to paint. It is a mental process similar to an author searching for the right story plot, the right characters or the right words to communicate with his readers. In most paintings a careworn broom would be just an incidental detail, slurred over and rendered in haste. To me it is a passage to be savored and executed with enjoyment and a kind of reverence. Beauty is there and an appreciation of what's real, of how people live day by day in their environment.

From cradle to the grave we are surrounded with natural and man-made objects, many of which can serve as a theme for a painting. Almost any subject when treated with care and respect can relate to the human condition in a meaningful and poignant way. This is the intent of many of my pictures.

The family wash drying on a clothes line outdoors is not such an unusual sight even in this era of automatic dryers. Certainly, it was a very common sight in 1936 when I painted the laundry pole shown on the opposite page. In those days nearly every household in city or country had some equipment suitable for open air laundry drying. The silhouette of the old, much used clothes pole with the rhythmic drape of the time worn ropes seemed to capsulize a common but significant story.

To have the subject tell the story certain factors need to be considered. What are the forces that work on this object that make it look unique, make it different than a new one? To ask the questions usually supplies the answers. Obviously, the wind whips the pole around on good days and bad. With a burden of heavy, wet wash the stresses on the pole are akin to that of a ship's mast in a gale. Other elements have their say; winter frosts heave the pole in many directions away from the vertical in which it was planted. And what of the human element? Should people be included in the scene?

All of these things went through my mind before I started to paint. The first step was to search the setting and select the right story telling spot. The house in front of the laundry pole could well have been the subject. In this case I liked the pole. I also thought there was no need to show people. The presence of the housewife is felt. You know she is around somewhere and there is no need for specific identification. In a similar way I think the viewer knows there are some wooden clothes pins in the basket resting in the grass.

Subject matter exists everywhere—sometimes where you least expect it. On one occasion I recall, I was intrigued with the painting possibilities of three store fronts with apartments in the upper stories. Before setting up my easel I had an impulse to walk around the rear of the buildings. There I found my picture. It was a much better subject to paint, a more human situation. Porch balconies and stairways—lines of wash hanging out to dry and cars parked at random. The scene spoke eloquently of the building's inhabitants. That was the story to tell.

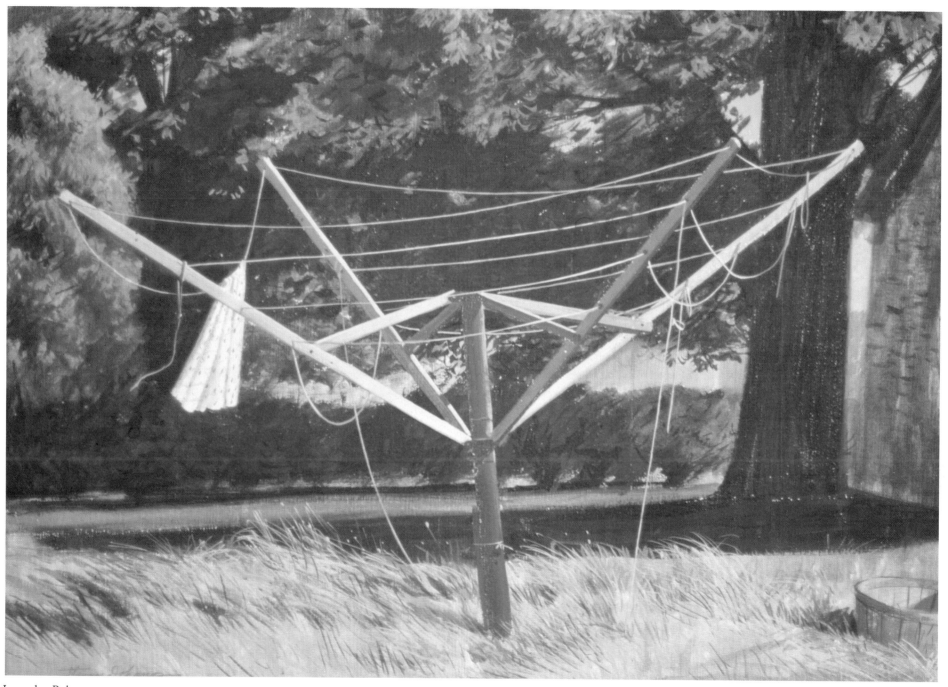

Laundry Pole

15 × 22 inches Watercolor on Whatman Board

19

The flavor and quality of any town's life is best observed on Main Street. Everyone of every age enjoys "going downtown." Even the words *Main Street* carry a meaning and kind of magnetism. As an artist involved in depicting America's daily life and emotions it is inevitable many of my paintings relate to the hub of the community.

For me the drive downtown can be a rewarding experience. There is always something new to note and ponder. Sometimes I find myself reconsidering areas and objects that have already found their way into one or more of my pictures. The church, the fire house, a school, a ball field, roadside stands of fruit and flowers, all have meaning and visual excitement that varies with the season and the light. The impressions are eclectic and flow with the movement of the automobile. I gather bits and pieces of story telling material like a busy squirrel and store it in my mental filing system.

The action and sights become more kinetic the closer I come to the center. More cars, more people, more stores. The store fronts and shop displays, showing every sort of merchandise, excite the eye and stimulate the mind. The shoe shop, the gourmet shop, the supermarket, the hardware store and people of every age, shape and color, no two dressed alike . . . all meld and blend in a whirling panorama making the juices of the artist flow.

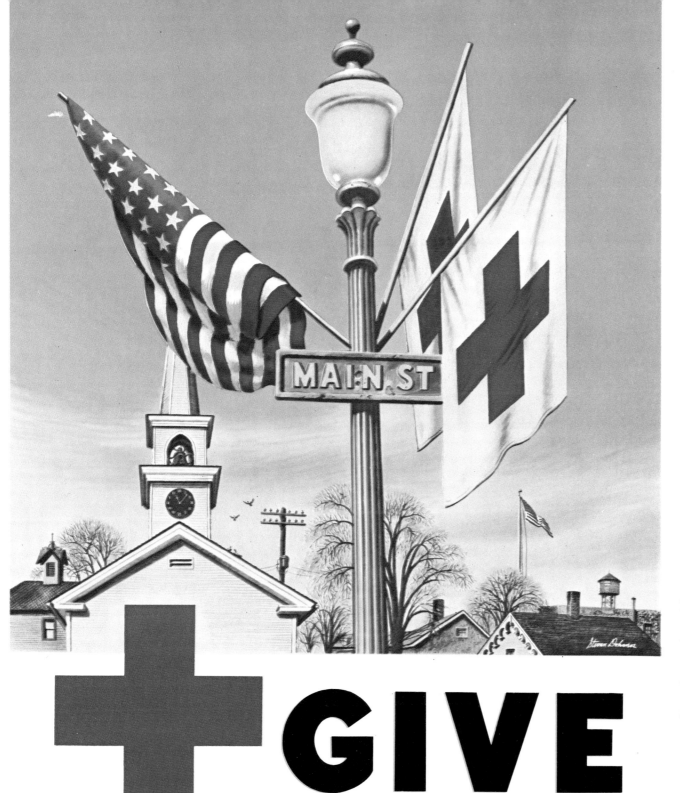

A Street Lamp Becomes a Poster Motif

This poster designed for the American Red Cross was used in their annual fund raising drive. The American flag and those of the Red Cross suggest the national importance of the drive while the Main Street marker helps identify every community and individual with this national effort. All the symbols used in this poster such as the rooftop, the church steeple, the clock and the telephone pole further identify this cause with elements typical of American towns. These familiar objects all combine to express a storytelling idea.

21

Saturday Evening Post Covers

On the following pages are a random selection of some of my favorite Saturday Evening Post covers. Over a 15 year period I painted more than a hundred covers for this family magazine. My first one appeared in December 1943. To me they represent and mirror some of the aspects of American life during the 40's and 50's.

A magazine cover, unlike a fiction illustration, cannot rely on a caption to describe the scene. The cover stands alone and must communicate its story without words. Cover ideas stem from personal experiences and observation by the artist of his home life, daily contacts with neighbors, local community and events that are seasonal or national in scope.

An experienced cover artist is constantly on the alert for picture situations that he can develop in his own personal style of painting. Throughout the working year countless ideas are recorded in sketch form and periodically submitted to the art editor of the magazine. Only a few are chosen to be made into finished paintings and grace one of the 52 yearly covers required by the publication.

Most of my covers featured people and places near my studio in a rural setting, posed carefully with selected people. I seldom used professional models. This seemed to add a believability and universality to the cover story. My special effort was to create covers that could be "Anytown U.S.A."

In this period of working for the Post I submitted about five cover idea sketches for every one that was chosen—a batting average of 200 is not considered bad for the majors in mass publication. To accomplish this my radar had to be on the alert at all times to pick up every possible situation that could be built up into a cover idea. Covers are seen by millions of people and they serve as a record of the times. The audience is eager, attentive and alert. The artist must do his research homework carefully. I am grateful I had the opportunity to add my voice to the telling of this fragment of the American story.

Delayed Ball Game

July 20, 1946
©The Curtis Publishing Company

23

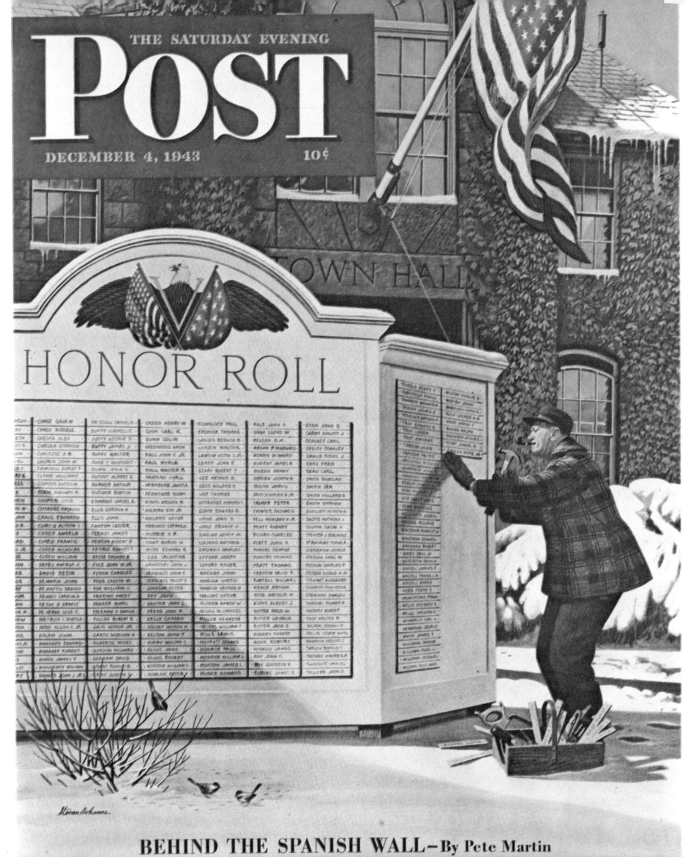

Honor Roll

December 4, 1943
©*The Curtis Publishing Company*

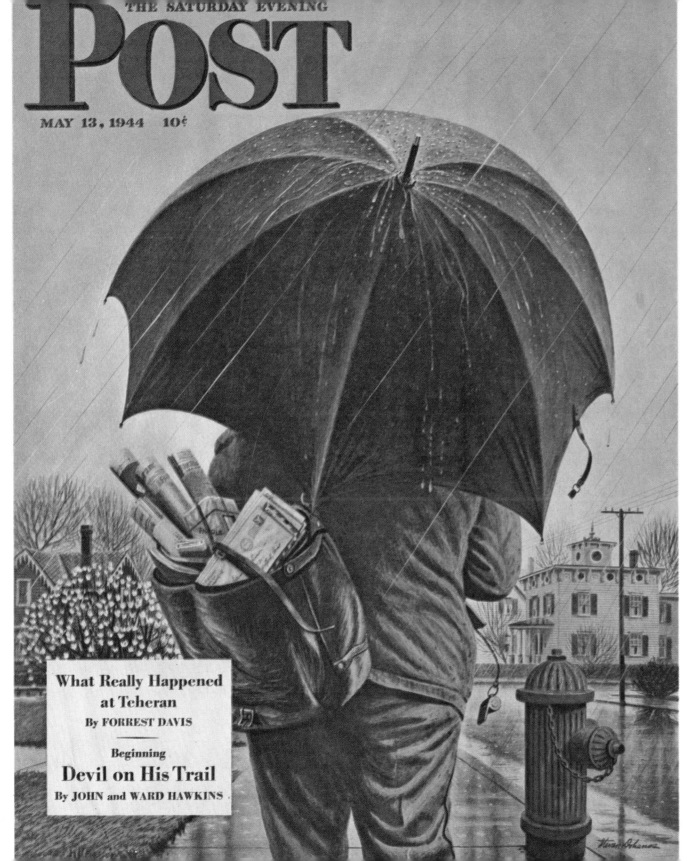

Mailman in the Rain

May 13, 1944
©The Curtis Publishing Company

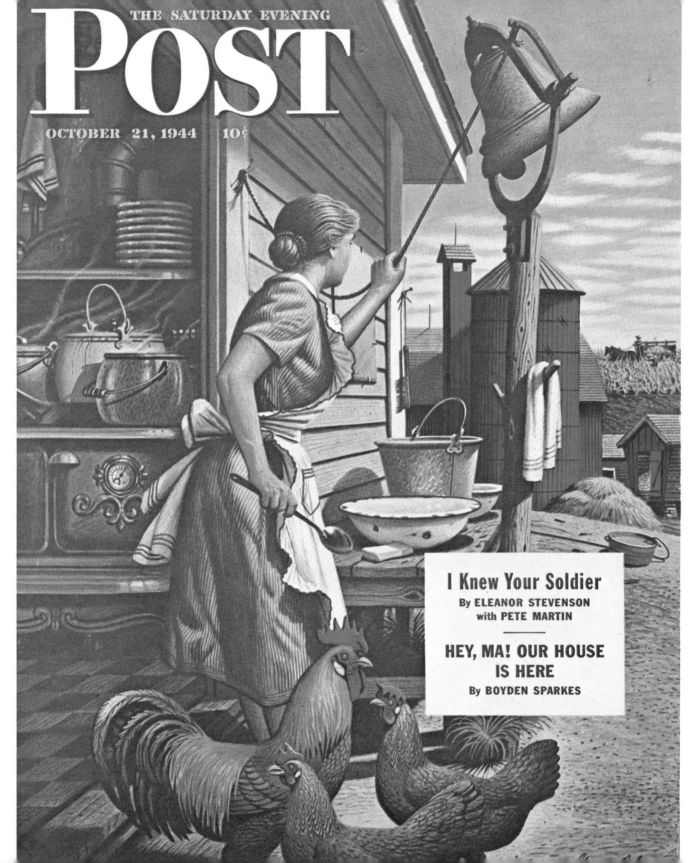

POST

OCTOBER 21, 1944 10¢

I Knew Your Soldier
By ELEANOR STEVENSON
with PETE MARTIN

HEY, MA! OUR HOUSE
IS HERE
By BOYDEN SPARKES

Farmer's Dinner Bell

October 21, 1944
©The Curtis Publishing Company

26

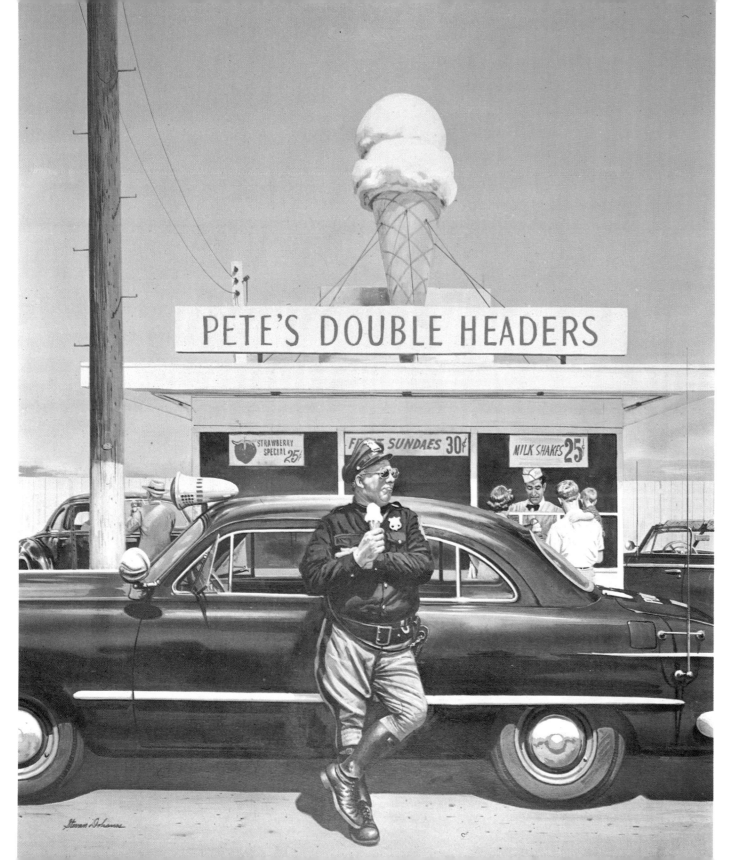

Ice Cream Break

September 22, 1951
©The Curtis Publishing Company

27

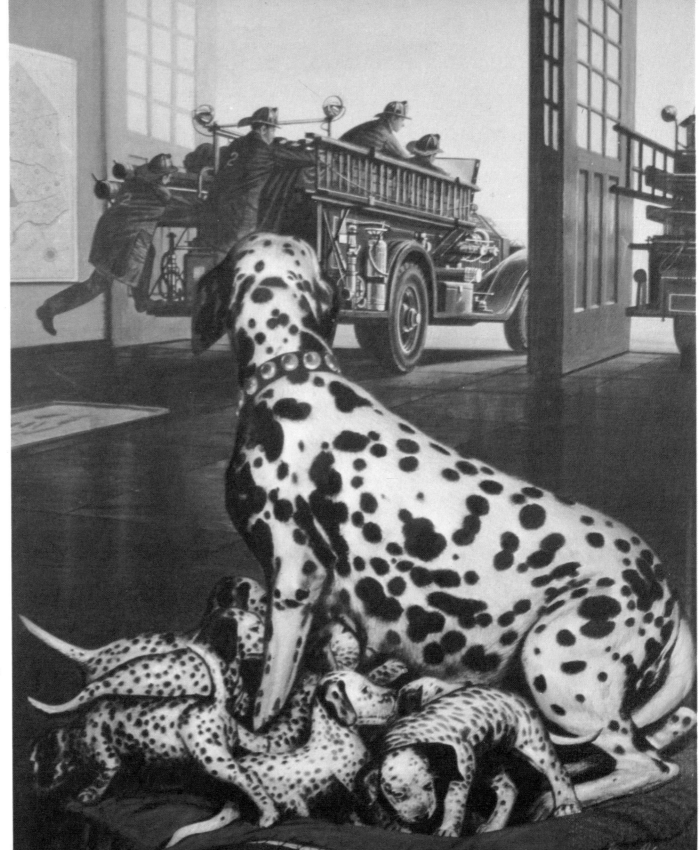

Firehouse Dalmations

January 13, 1945
©*The Curtis Publishing Company*

28

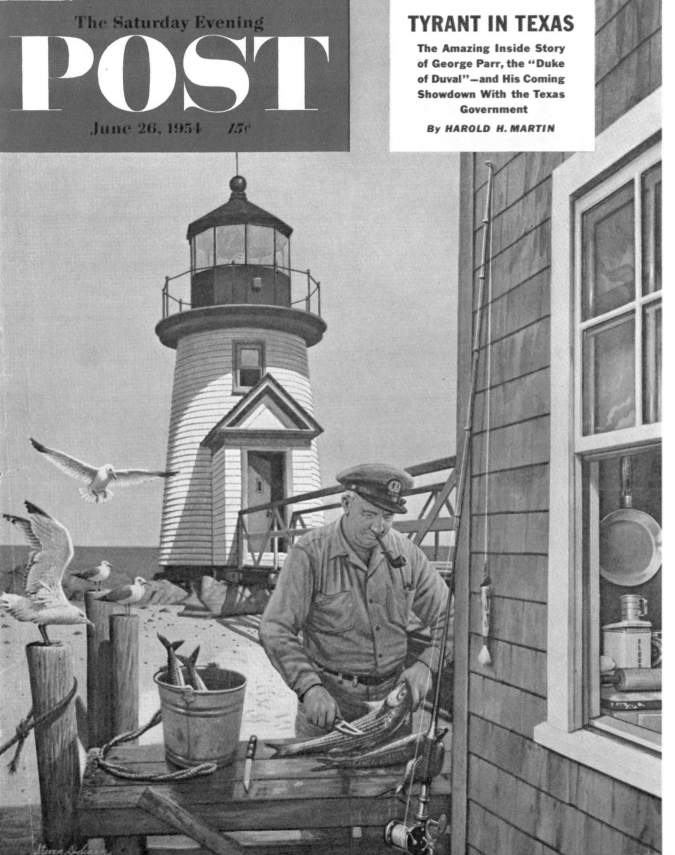

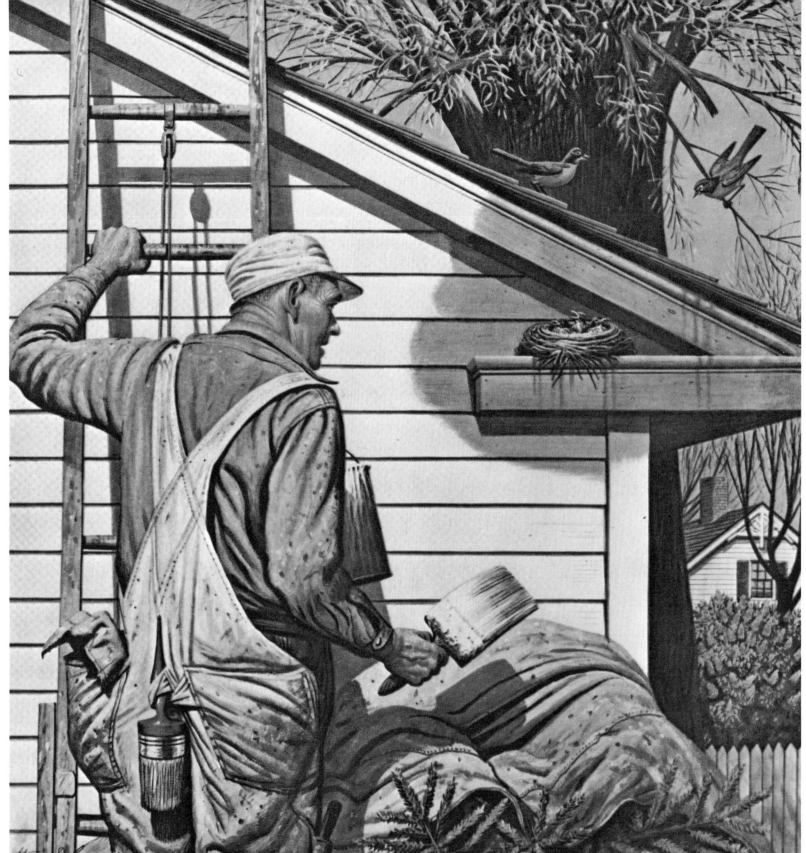

House Painter's Dilemma

May 12, 1945
©*The Curtis Publishing Company*

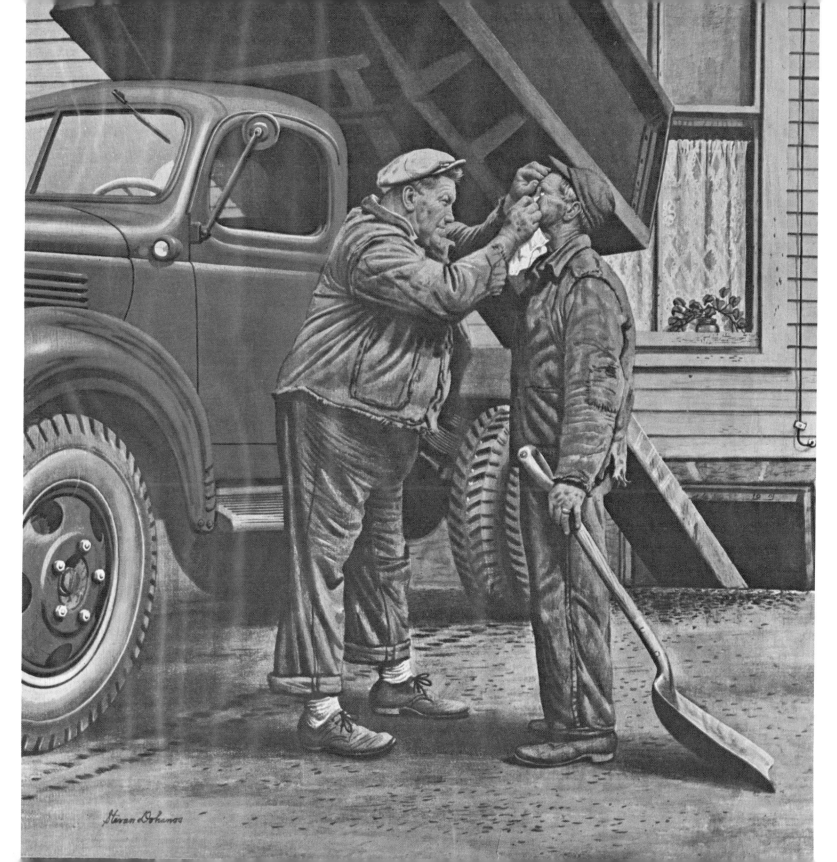

Coal Delivery

October 18, 1947
©The Curtis Publishing Company

31

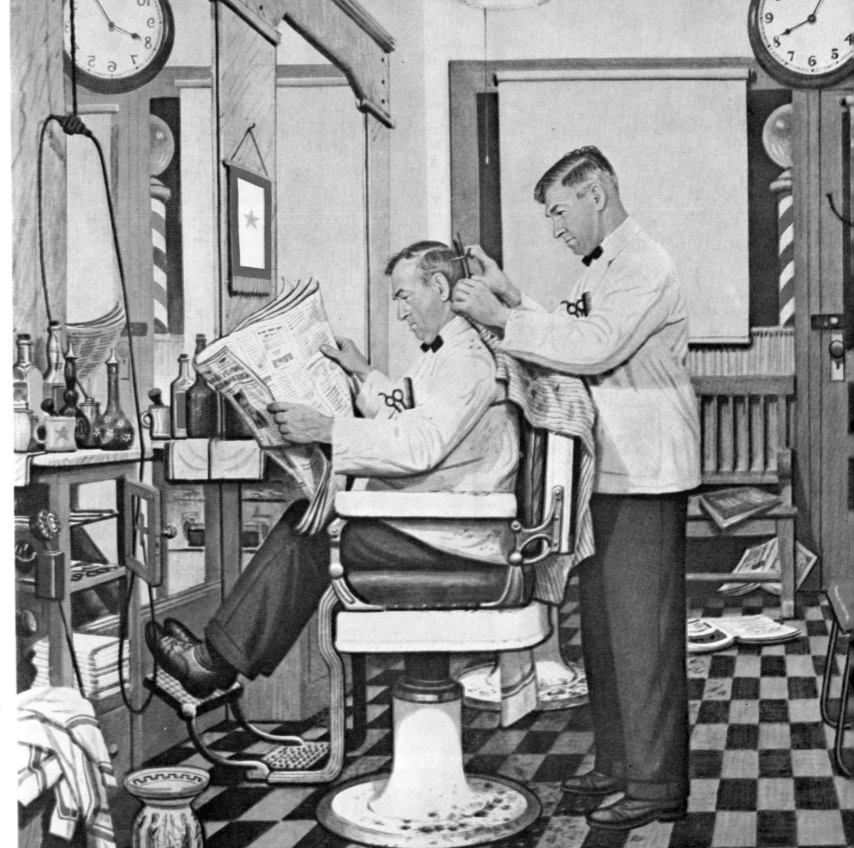

Free Haircut

January 26, 1946
©*The Curtis Publishing Company*

32

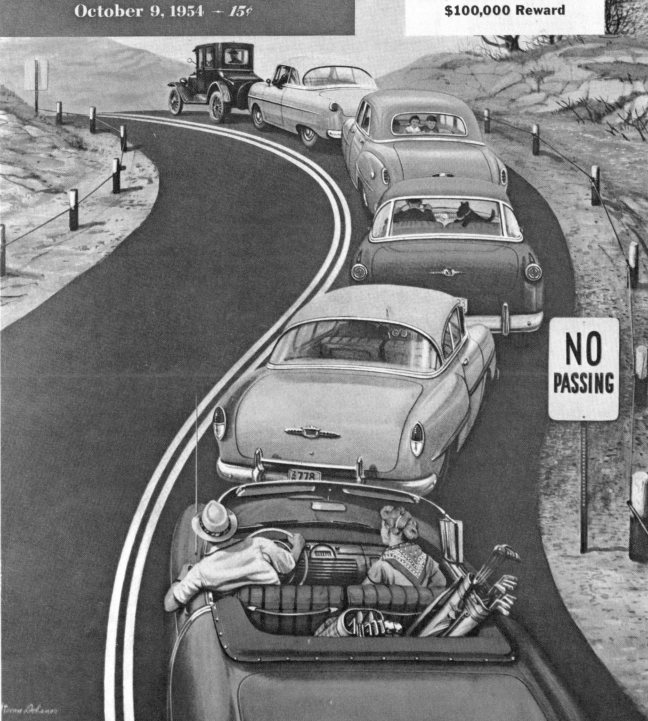

No Passing on Curve

October 9, 1954
©The Curtis Publishing Company

33

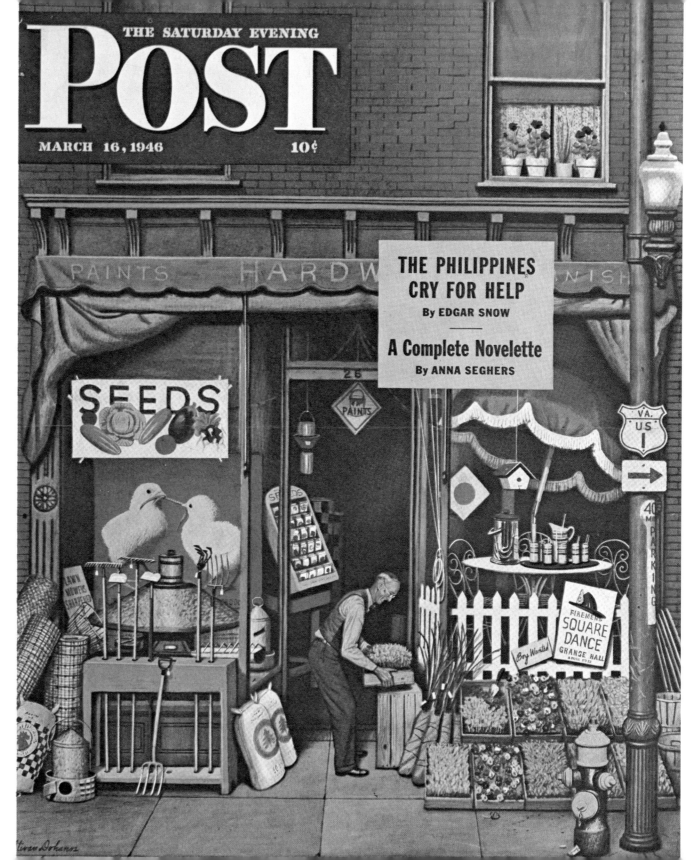

Seasonal Display

March 16, 1946
©*The Curtis Publishing Company*

Jalopy

May 20, 1950
©The Curtis Publishing Company

35

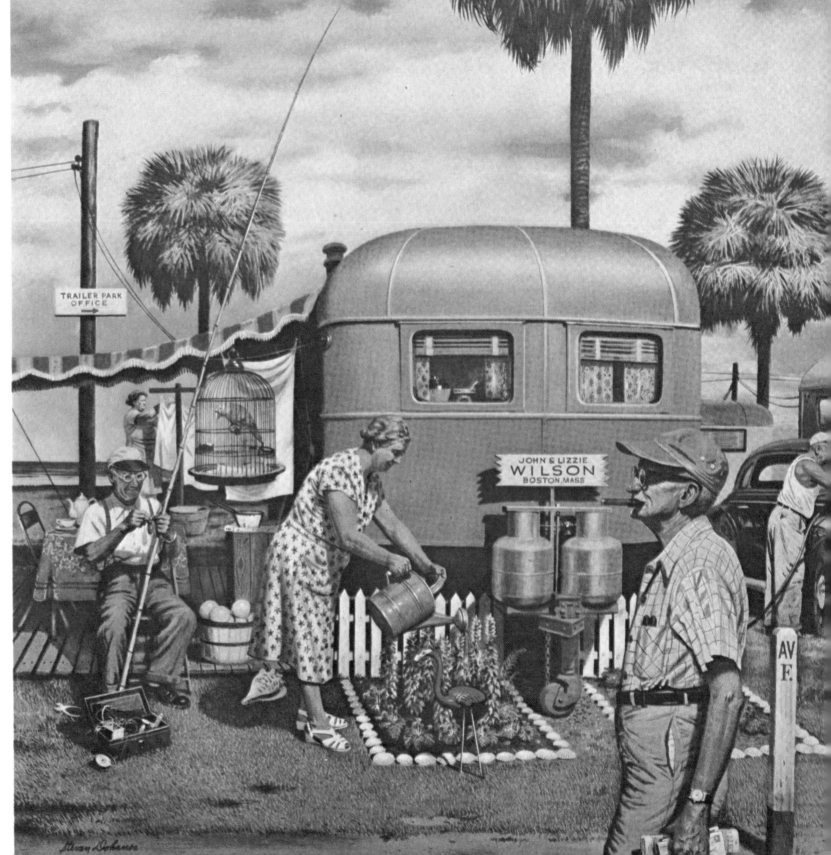

Trailer Park

February 2, 1952
©*The Curtis Publishing Company*

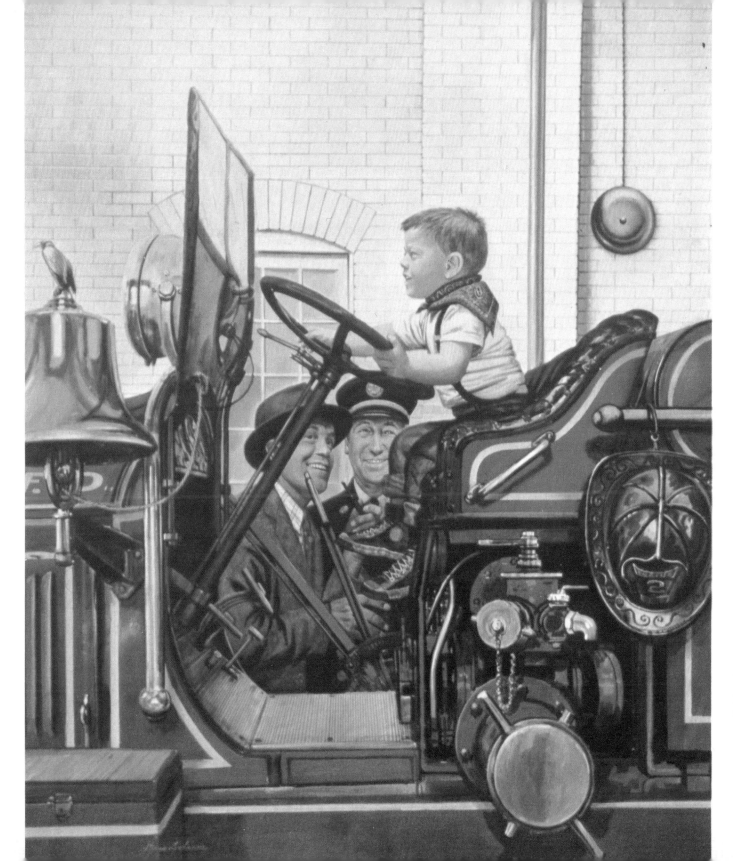

Future Fireman

November 14, 1953
©*The Curtis Publishing Company*

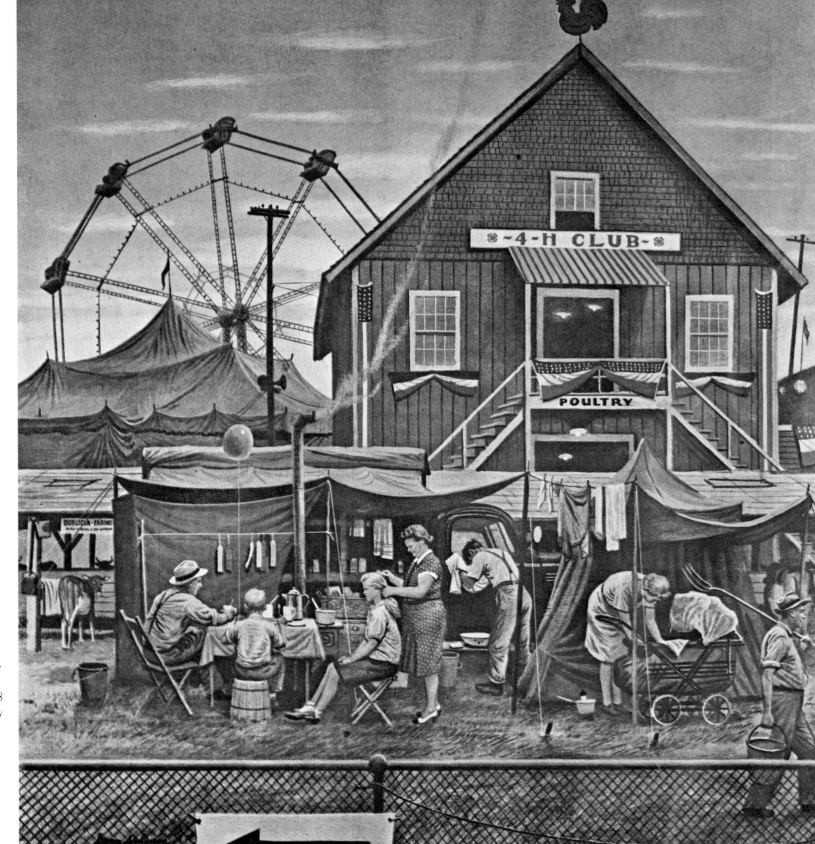

State Fair

August 28, 1948
©*The Curtis Publishing Company*

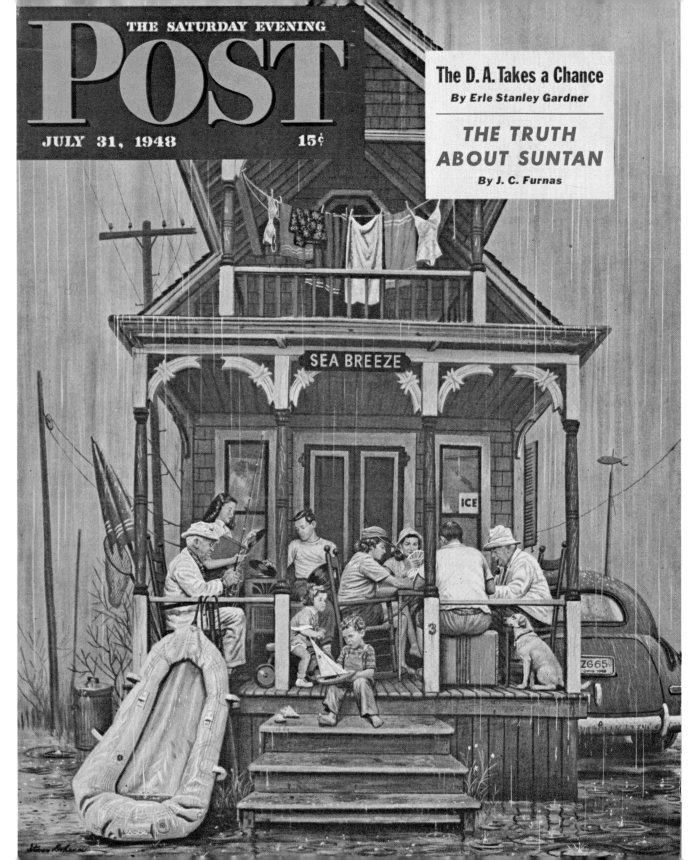

Rained-in Vacationers

July 31, 1948
©The Curtis Publishing Company

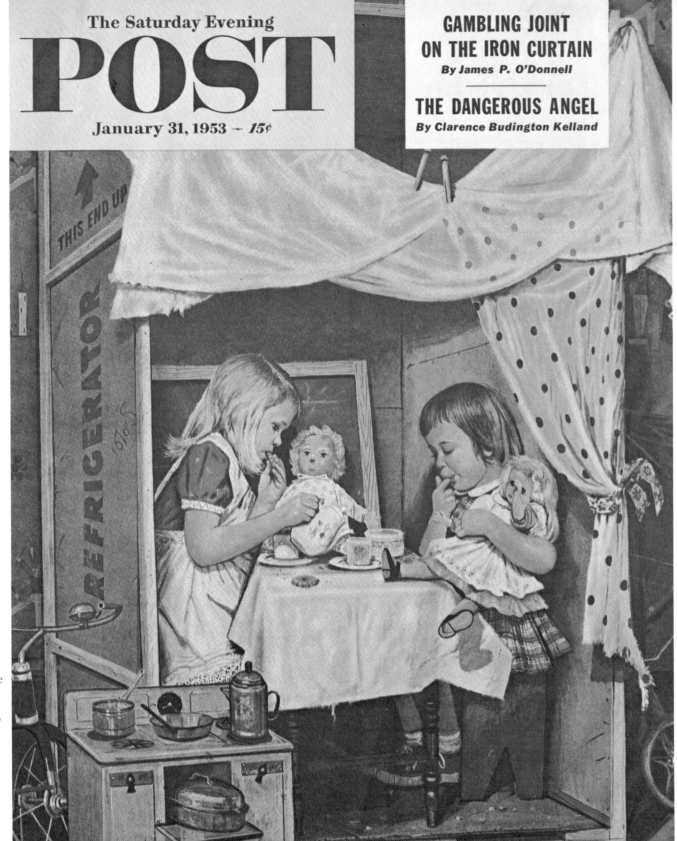

Tea Party in Packing Crate

January 31, 1953
©*The Curtis Publishing Company*

40

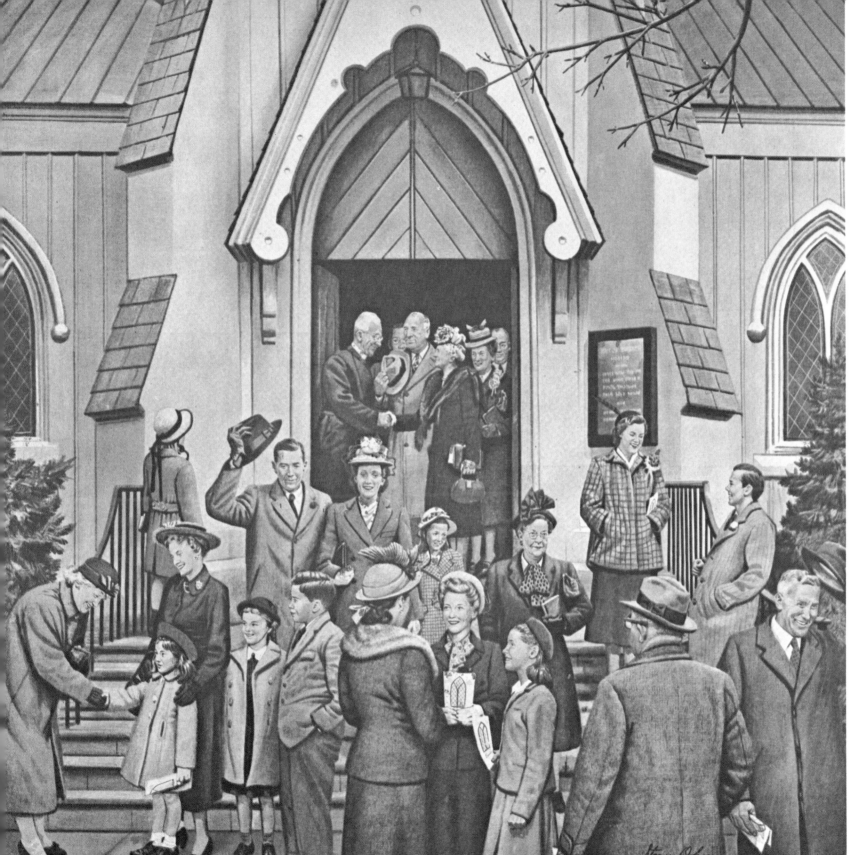

Church Service Ends

April 16, 1949
©*The Curtis Publishing Company*

41

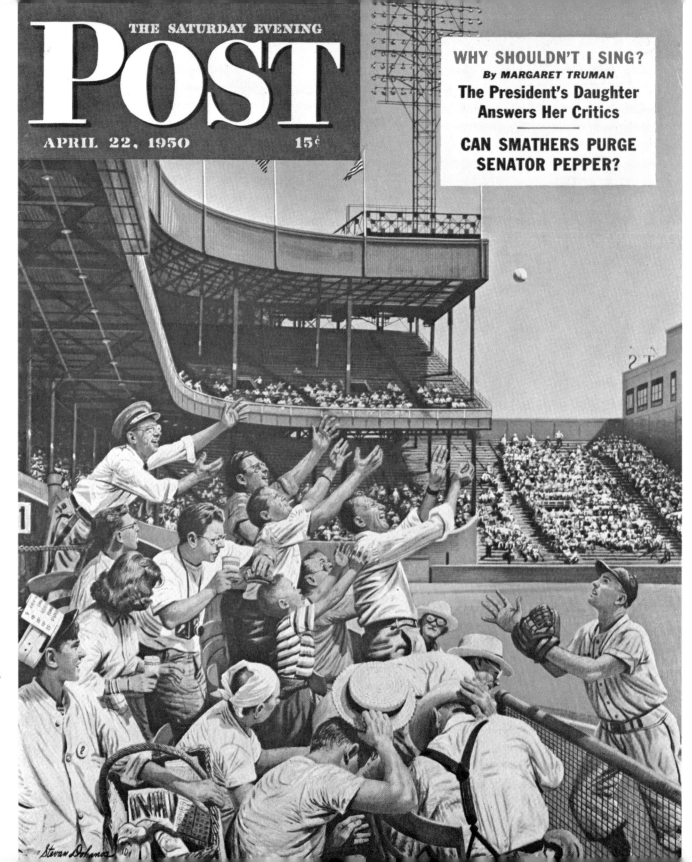

Foul Ball, Polo Grounds

April 22, 1950
©*The Curtis Publishing Company*

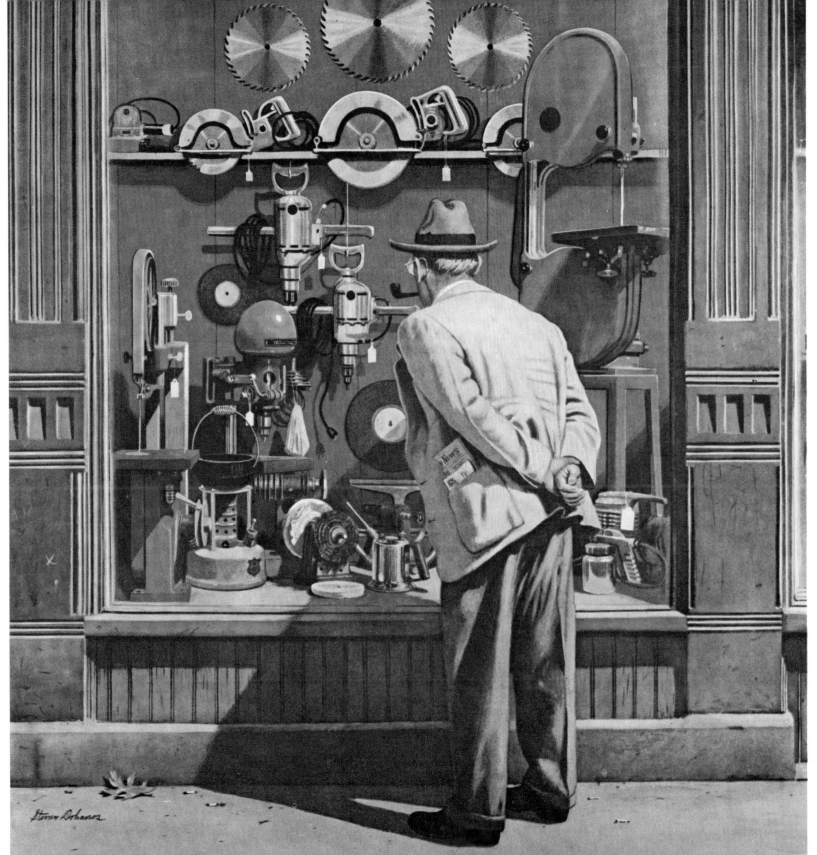

Window Shopping

Nov. 10, 1951
©*The Curtis Publishing Company*

43

Medical Times before redesign.

Medical Americana

With the demise of the weekly Saturday Evening Post an important exposure area was lost to the artists who contributed regularly to this popular family publication. The Post's cover paintings were in effect weekly chapters, reflecting contemporary life in America. A mirror of many moods ranging from the humorous to the most patriotic and serious themes.

With cover artists such as Norman Rockwell, John Falter and others, I contributed my share of pictorial observation of my fellow citizens spanning a fifteen year period of my career. Needless to say, I look back upon these years with pleasure and satisfaction. But it came to an end, and I had to look for new markets for painting the American Scene.

In the course of events I was invited to restyle Medical Times, a monthly medical journal into its new format. For the next seven years I art directed twelve covers a year, designing and painting four a year.

I commissioned two other artists, Alex Ross and Melbourne Brindle, to produce the others.

The family doctor's activities as well as the general field of medicine were explored for good picture situations. The first cover in this series is shown on the opposite page. It illustrates a family doctor making a house call to a patient stationed in an offshore lighthouse. The theme of the series was to show practicing M.D.'s in responsive human terms.

Medical Times after redesign.

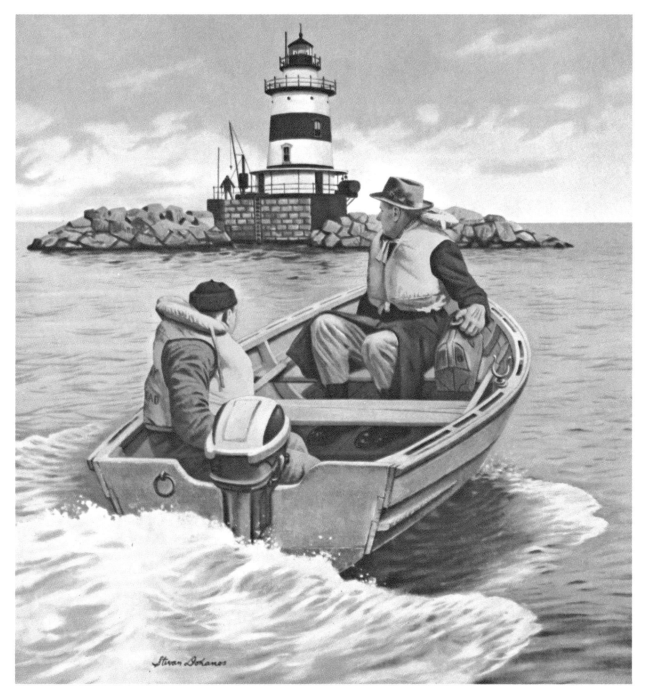

Courtesy Medical Times

Yankee Team Doctor

I was fortunate to have as a personal friend Dr. Stephen Gaynor, an orthopaedic specialist at New York's Lennox Hospital, who helped out on this cover assignment. Dr. Gaynor, in addition to his private practice, was the official physician of the New York Yankees. He traveled to the spring training quarters in Florida and was "on call" at home games in Yankee Stadium. With the good doctor "running interference" for me, I was allowed to invade the ball club's medical and therapy quarters to photograph background material and to pose some of America's most famous athletes receiving medical attention. It was exciting as it all took place just prior to a crucial World Series game.

Courtesy Medical Times

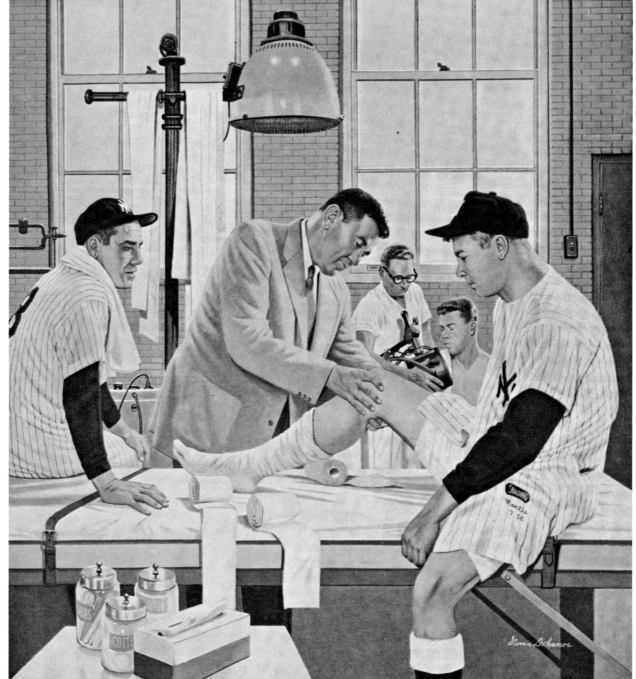

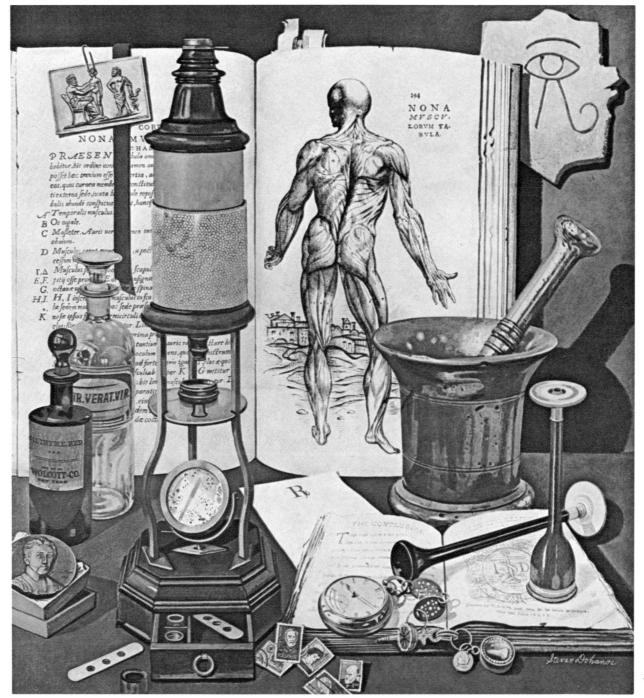

Medical Memorabilia

"Medical Memorabilia" is an example of careful museum and archival research. Historical documentation is an important factor in a still life arrangement of this sort. The painting attempts to summarize a chapter to man's medical knowledge and history; reaching back in time for information while simultaneously pushing forward to show the state of the science today, and suggesting what the future may hold. Careful and accurate research is the name of the game if the artist is to serve as a historian. For each assignment I gather far more material than I can ever use in my painting. I find this rewarding in many ways. First and foremost it gives me confidence to proceed—I know what I'm doing and I can back it up with facts. Facts are important to me. Without them I feel insecure.

Courtesy Medical Times

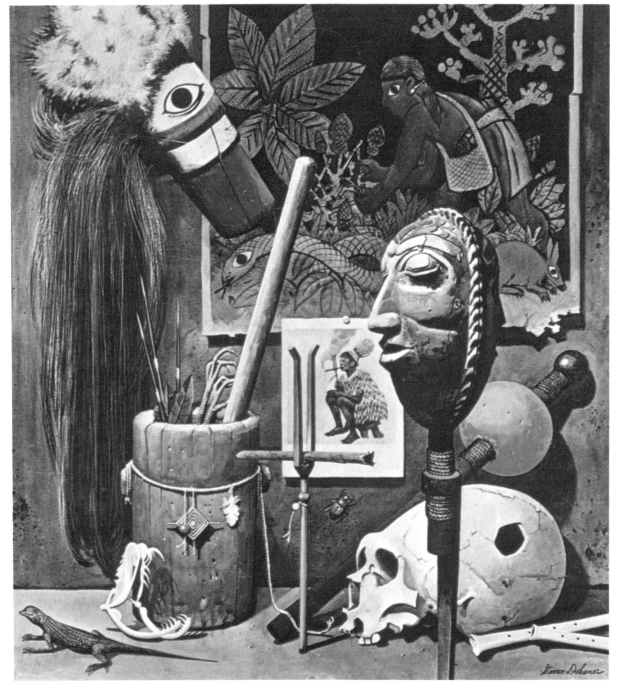

Witchcraft Medicine

This is a montage of the common tools of the primitive medical man. All of the items shown are based on authentic museum artifacts. For instance: in the print on the wall the 'doctor' is seen gathering medicinal herbs; the mortar and pestle was used to grind up healing concoctions of chicken bones, porcupine quills, lizard and snake bones. It was thought tobacco smoke blown in the face of a patient would relieve pain. The gourds were used to make rattling healing sounds and the ultimate cure supposedly was to carve a hole in the patient's cranium to release inner evil spirits.

The research involved with each painting becomes an added dimension making each picture, no matter what subject, more interesting and enjoyable.

Courtesy Medical Times

48

American history told in postage stamps

think small

Apart from its primary purpose of showing payment for the delivery of mail, the postage stamp has become a special art form communicating ideas of national importance. These mini-posters, printed in the billions annually, carry the story of America at home and abroad. Stamps on letters cross international borders, thereby becoming a nation's calling card. Stamps communicate our noblest ideas and ideologies, express our heritage, our goals and pride in our democratic way of life. Stamps are miniature windows presenting America's past, present and future. They display a wide spectrum of our culture.

For a number of years I have served on the Postal Service Stamp Advisory Committee as an art advisor.

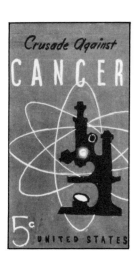

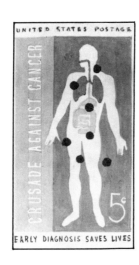

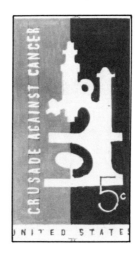

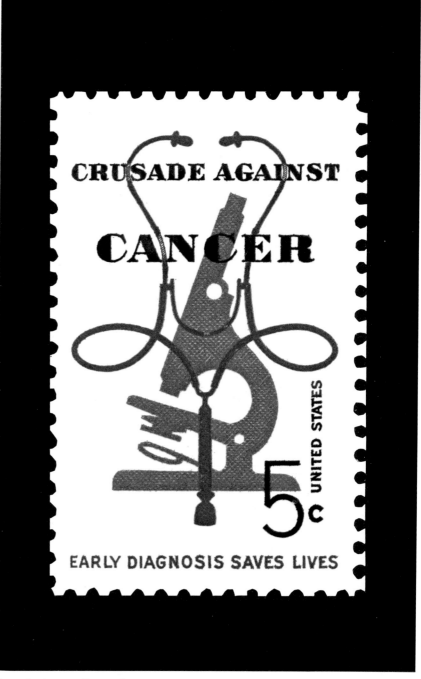

Crusade Against Cancer Stamp
Issued April 1965, Washington, D.C.

The committee is responsible for the design of every U.S. postage stamp. Designing a stamp confronts the artist with unique problems. This is how the procedure works.

After the committee has decided on a theme for a new stamp an artist is selected to submit ideas on how to graphically express this theme. In an area a little less than one square inch, the designer must arrange many elements—the visual symbol or illustration—the title and text—the name of the country as well as the denomination of the stamp. He is restricted in the number of colors he can use. Historical accuracy is vital. At times existing art from our art museums is made available to the Stamps Division of the U.S. Postal Service. Archival material and reference is searched out from private and public services and utilized. Only after the design idea is

accepted is the artist authorized to execute the finished work. This is done in scale, usually many times larger than the finished stamp.

Government policy prohibits the designer from signing his work. Each designing artist is selected on the basis of his proven talent and his expertise in a special and specific subject. The stamp therefore is designed and illustrated with authority. Purchase of a stamp is a purchase of a work of art. Also, a stamp is one of the world's largest collector's items. It is estimated there are over twenty million people of every age who are active philatelists.

On these and following pages are a few of the many stamps I have designed. Each stamp assignment is a special challenge.

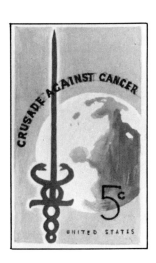 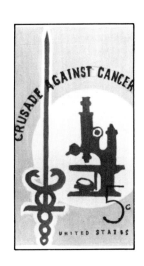 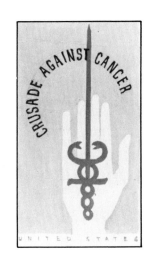 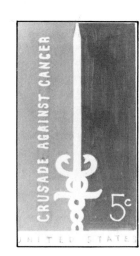

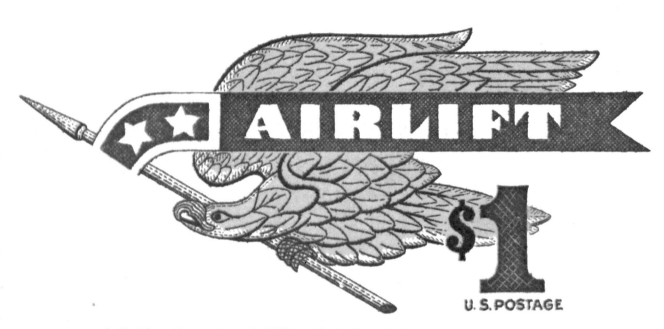

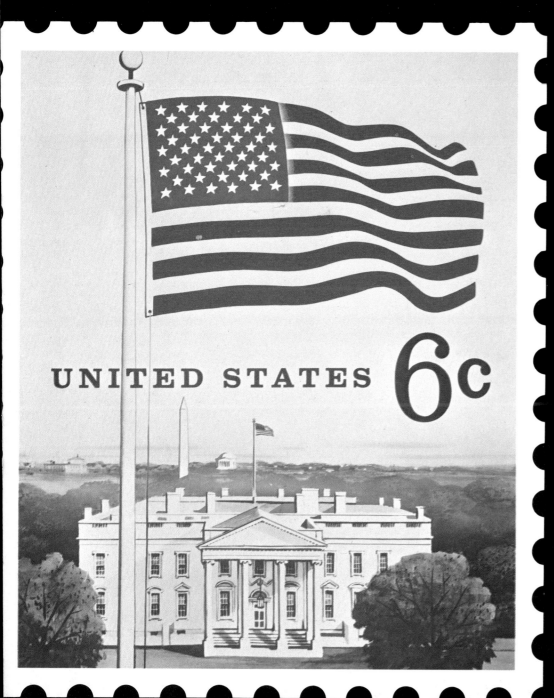

UNITED STATES 6c

WE APPRECIATE OUR SERVICEMEN

UNITED STATES SAVINGS BONDS

25TH ANNIVERSARY 5c

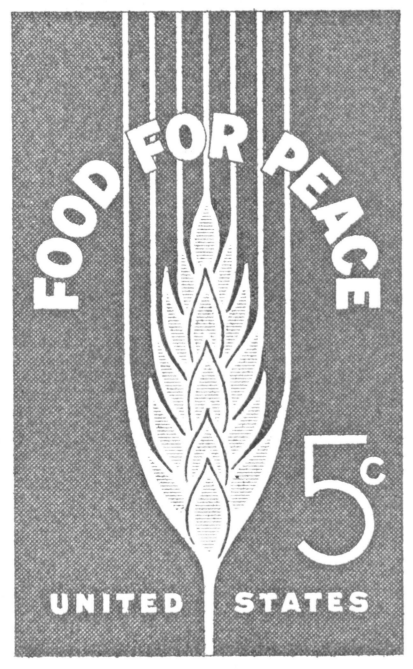

FOOD FOR PEACE

UNITED STATES

5c

FREEDOM FROM HUNGER

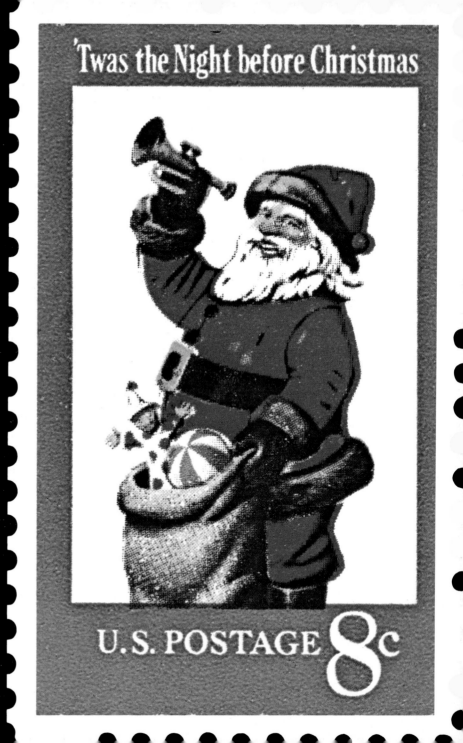

'Twas the Night before Christmas

U.S. POSTAGE 8c

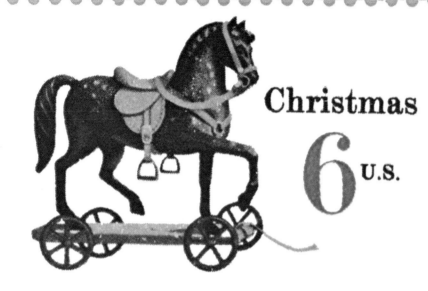

Christmas
6 U.S.

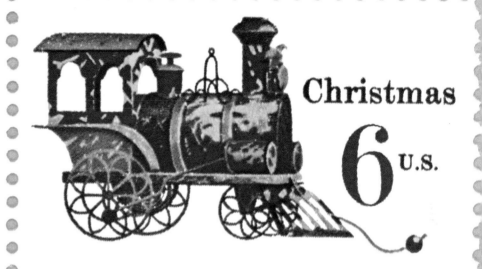

Christmas
6 U.S.

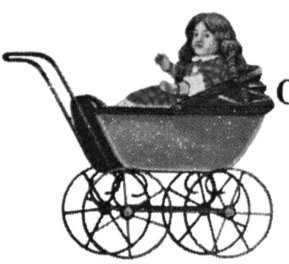

Christmas
6 U.S.

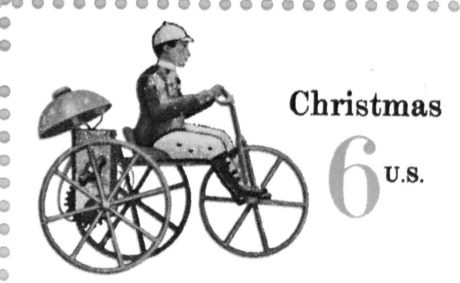

Christmas
6 U.S.

painting a still life *step by step*

Antique decoys have been a favorite subject in many of my still life paintings, so it was natural for me to select a decoy once again as the central object of a demonstration painting. The following pages present the step-by-step procedure of the painting of "Canada Goose Decoy."

Weeks before beginning the painting I had a definite concept of what I wanted to do. I envisioned the decoy set on a workshop bench with all of the carver's gear and tools accurately described. To get it right would require research. Through a craft museum I learned of an expert decoy carver, David Ward, who lived about 60 miles from my studio. I made arrangements to pay him a visit. As a result of my pilgrimage to the workshop, I commissioned Mr. Ward to carve a Canada Goose decoy especially for this painting.

Arrangements were made for me to return some weeks later with a photographer at which time I would set up the newly carved decoy in a realistic still life composition. In this way I could capture the atmosphere of the shop with all its interesting equipment and clutter. Eight of the photos taken that day are shown in the film strip on these pages.

On the scene my first decision, surprisingly, was to move from the interior of the workshop to a table outside of the building. The photos show me, with the help of Ward, carrying items of interest from inside his shop to the exterior setting. Changes of concept were made from minute to minute while on location. This is known as the creative process. Careful selection and arrangement of elements in a still life is as basic and important as the act of painting.

The photographs we made enabled me to paint the still life in my own studio at my convenience. It also eliminated the need to interfere with the busy wood carver's schedule.

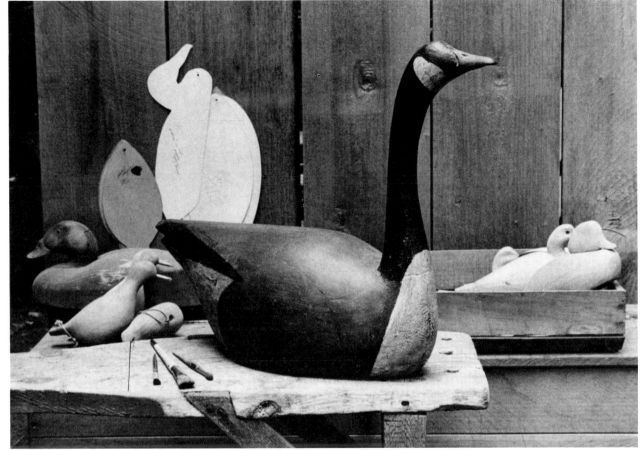

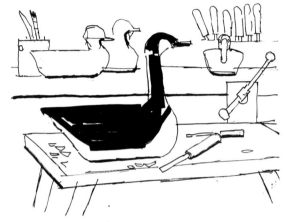

Photograph selected as a basis for final painting.

Thumbnail sketch of my original picture concept prior to research and field work.

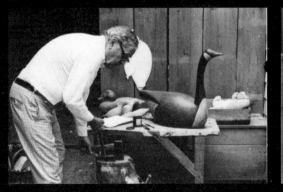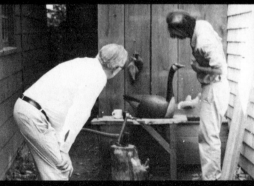

KODAK SAFETY FILM 5062　　KODAK SAFETY FILM 5062　　KODAK SAFETY FILM 5062

→1　　→1A　　→2　　→2A　　→3　　→3A　　→4　　→4A

photographs by William Noyes

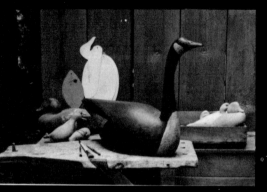

On location at a decoy carver's workshop

Paintable objects abounded in Ward's workshop. Every bit of floor, wall space and table surface was filled with interesting material. The only thing lacking was the right place to display the Canada Goose decoy. The photographs show my struggles to establish a simple workshop background outdoors. I was taken by a stump of wood in which an axe and hatchet were implanted. We carried it outdoors. Also, I liked the cardboard decoy templates that were hanging on nails along the walls in the workshop. To play it safe everything we arranged was photographed. As is usually the case, a great deal was left out of the final painting, but it was nice to know the information was available if needed.

Back in my studio I began the painting on a three foot by four foot panel of builder's Homosote. The smoother side of this board has almost canvas-like texture and is a middle gray in color. Flat latex wall paint and Shiva casein tempera tube colors were used to get the desired color nuance.

58

Step one

With the photographs as a guide, I made a pencil drawing directly on the smoother side of a raw, 3 × 4 foot Homosote panel. (Homosote has a nice texture and doesn't require a lot of preparation. I like working on it.) One of my first concerns was to make sure that the vertical lines defining the wide wall boards would separate well behind the decoy. I didn't want the strong lines bisecting crucial sections of the bird, creating unhappy tangents, etc. Also, I wanted to create interesting background shapes. Once the placement of the verticals was determined a T-square was used to rule them in.

I began the painting by rendering the strong black neck of the goose. This graceful area is an important design element in the painting and I brushed it in carefully.

The basic colors and values were indicated on the decoy and the foreground benches. This was done broadly with a wide brush using flat opaque tempera. Because I had set up the still life in outdoor lighting the decoy picked up a pronounced blue reflection from the sky. This reflection is now strongly indicated but later will be made to blend with the surface texture and patina of the decoy. Cool colors were indicated for the entire painting to distinguish it from a still life set in an interior setting with workshop lighting.

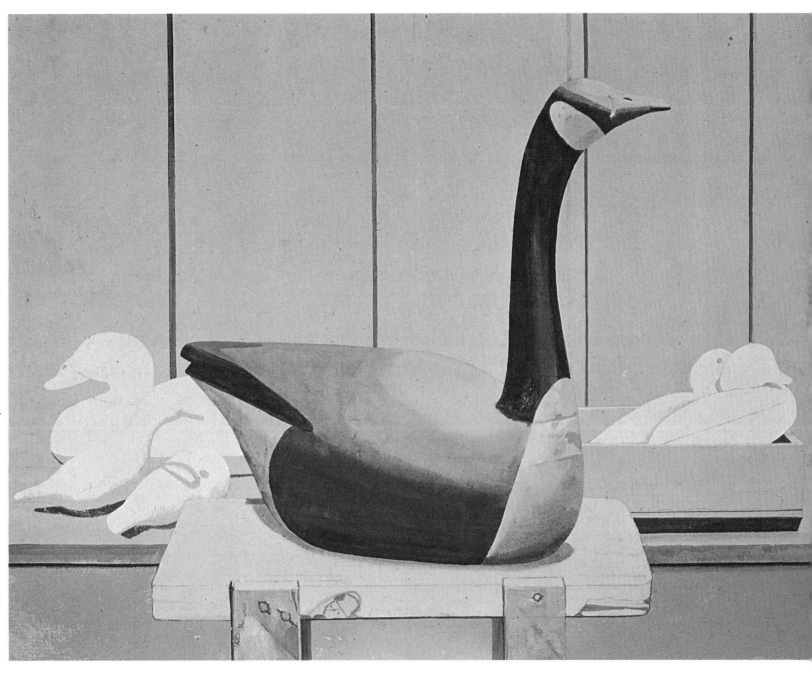

59

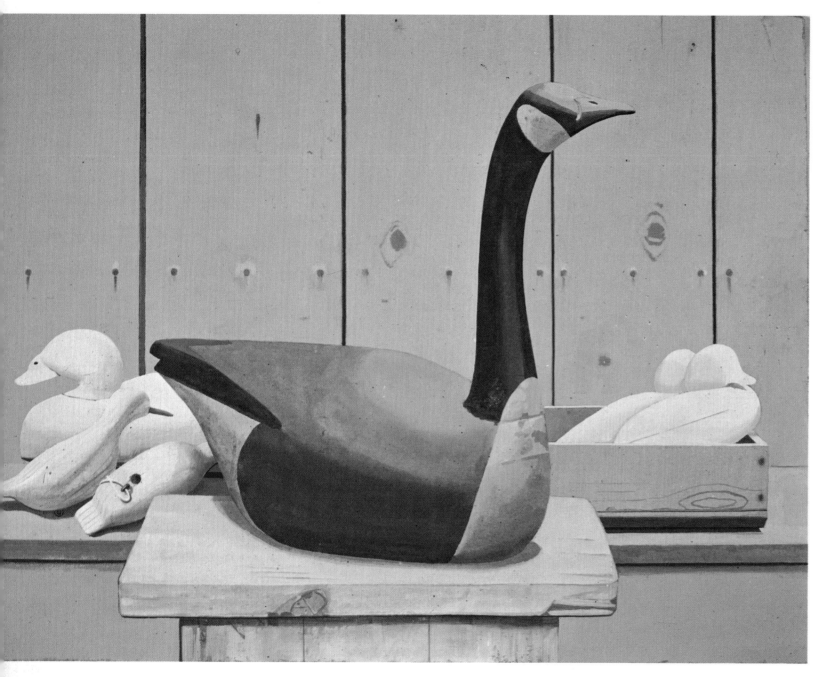

I felt the need to change the under structure of the rustic bench on which the decoy rests. The support needed to be re-designed. The original was an odd shaped three legged bench that did not visually explain itself or fit my purpose.

My next step was to add a cool weathered gray to the vertical boarding. Then the form and shapes of the miscellaneous decoys behind the goose were strengthened. The box on the right in which the decoys rest is left in the natural color of the Homosote. A strong light established on the table top in the foreground is strengthened to help separate the goose from the background and the other bench top items.

Nails and knot holes were suggested lightly as design elements.

Step three ▶

In painting directly from the Canada Goose decoy which is set up in my studio, I can render final surface nuances at a leisurely pace.

At this time I decided to remove the White Wing Coot decoy to help simplify the design. The decoy was removed by using a heavy layer of opaque tempera and painting the vertical boarding down to the top level of the bench. Here is an example of less being better because the focal point of the painting must be the Canada Goose decoy. I am also especially interested to make this central object appear solid and heavy. Please note that I have avoided excessive detailing of the grain of the wood panels.

By keeping flexible as the painting developed I was able to take advantage of design opportunities as they occured to me. I believe the final painting is improved because of these changes. You'll note in almost every case the changes involved simplifying. Usually the simpler the statement the greater the impact.

60

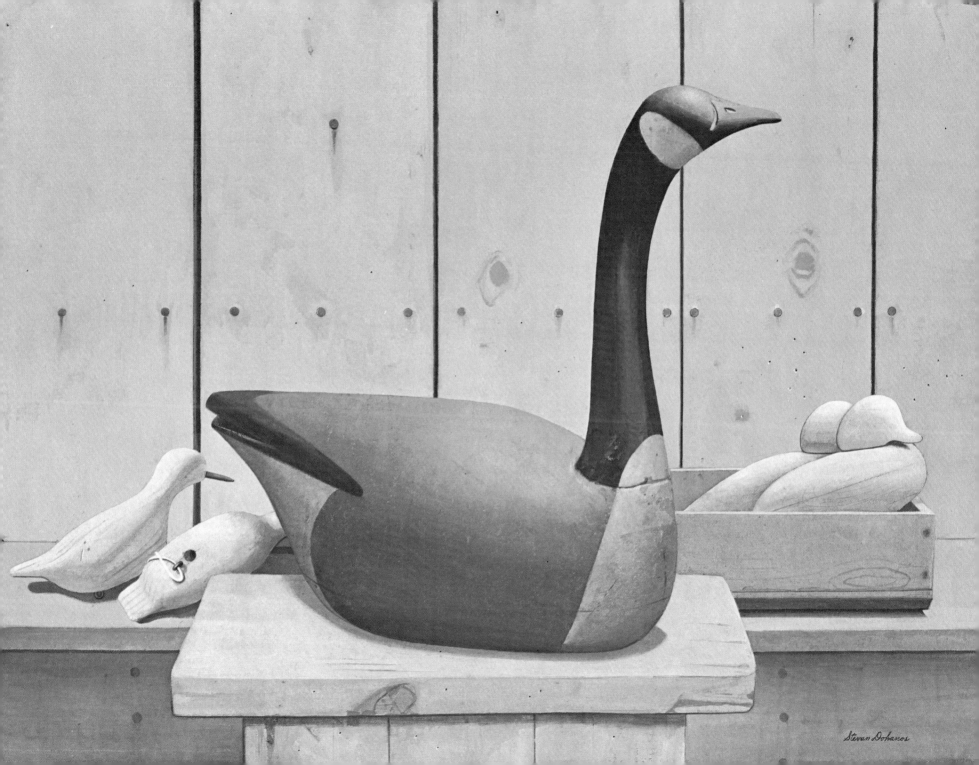

Stevan Dohanos

say it all in black and white

Throughout the years as a practicing artist, I have been intrigued with the dramatic effects achieved with the use of black as compared to working in multicolors. On the following pages are examples of black and white drawings, linoleum cuts, wood engravings and art produced on lithograph stones. All are traditional methods of reproducing a picture image with black ink as the only color.

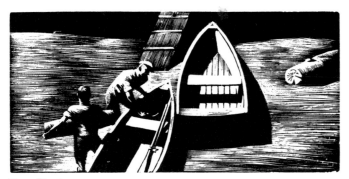

Two Dories
Woodcut Actual size

"Two Dories" is an example of a wood engraving. The print is the exact size of the wood block from which it is printed. The block is a special piece of hard wood, about an inch in thickness. The end grain of the wood block is the working surface, since it allows the engraving tool to cut freely in any direction. Before cutting, the smooth block is prepared with a coating of black ink. The image of the design is indicated with white crayon and acts as a guide for the cutting tool of the artist. Engraving tools are small chisels available in an assortment of cutting points. Each line hand-tooled out of the surface of the wood block will appear as a white line on the printed paper.

Whatever is not cut away appears in black. When the complete design is cut, a small printing roller saturated with printer's ink is rolled over the cut surface of the wood block. The inked block is then put in a hand printing press to transfer the design under pressure to the paper. Only one print at a time can be made.

Also shown are examples of linoleum block printing.

Cutting into a mounted piece of linoleum is quicker and easier for the artist and is recommended for the beginner. Before the advent of photo engraving most printing of poster, newspaper and publication art was done with hand engraved printing blocks or plates. The effects achievable by hand engraving have elevated the craft to an art form in its own right and many artists are specialists in this printing technique.

My early inspiration in the field of print making was inspired by such great talents as Rockwell Kent, Claire Leighton, Lynn Ward and others. I have designed many prints and was the proud owner of my own hand press in my basement workshop.

Black and white remains to this day an exciting contrast to the overwhelming color we are now exposed to in every area of publication. At times I feel we are subjected to too much color imagery. Occasionally the viewer should be allowed to imagine his own color. This is true of movies also. Black and white films can be quite stimulating and refreshing.

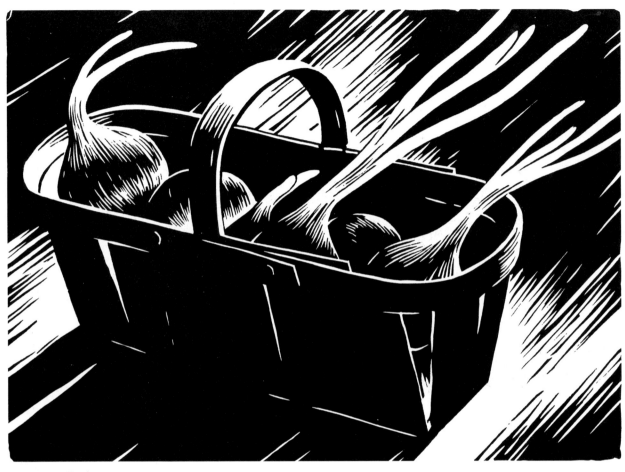

Onions in Basket
Linoleum block print 4¾ X 6½ inches (reproduced here in actual size)

Winter Morning
Linoleum block print 5½ X 7¾ inches

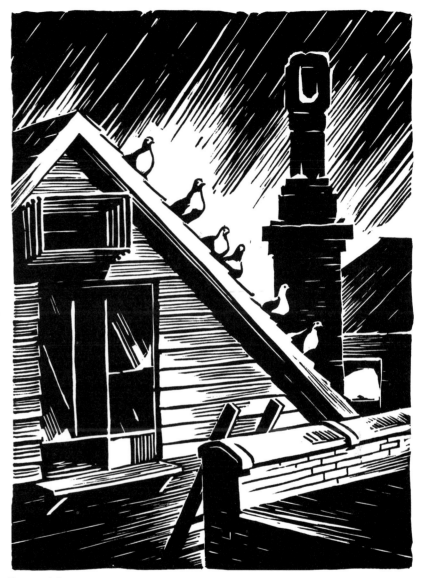

Pigeons' Roost
Linoleum block print 5½ X 7¾ inches

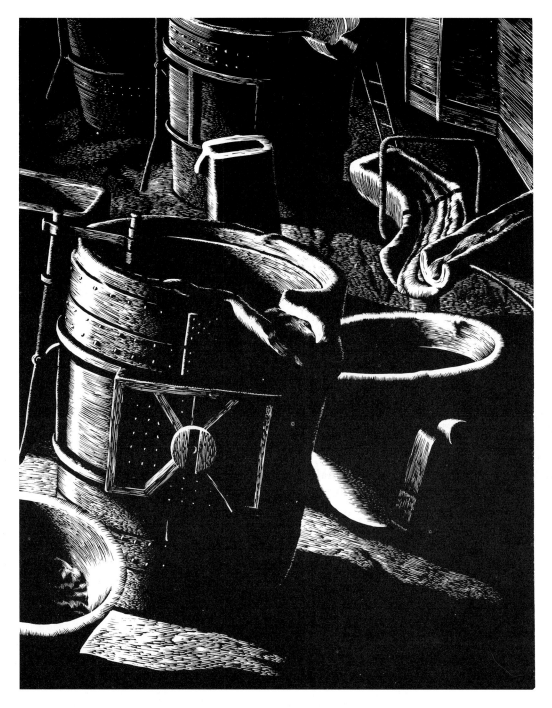

Blast Furnace Floor
Wood engraving 8 × 10 inches

The size and scale of the cauldrons in the blast furnace floor of a steel mill can best be imagined if you realize that the larger one in the foreground is thirty feet high. Huge cranes lift it when filled with hot molten steel. These cauldrons dwarf the steelworkers working amongst them. At one of my first jobs, I passed through this plant area daily. It made a lasting impression on me, which I later interpreted in this wood engraving.

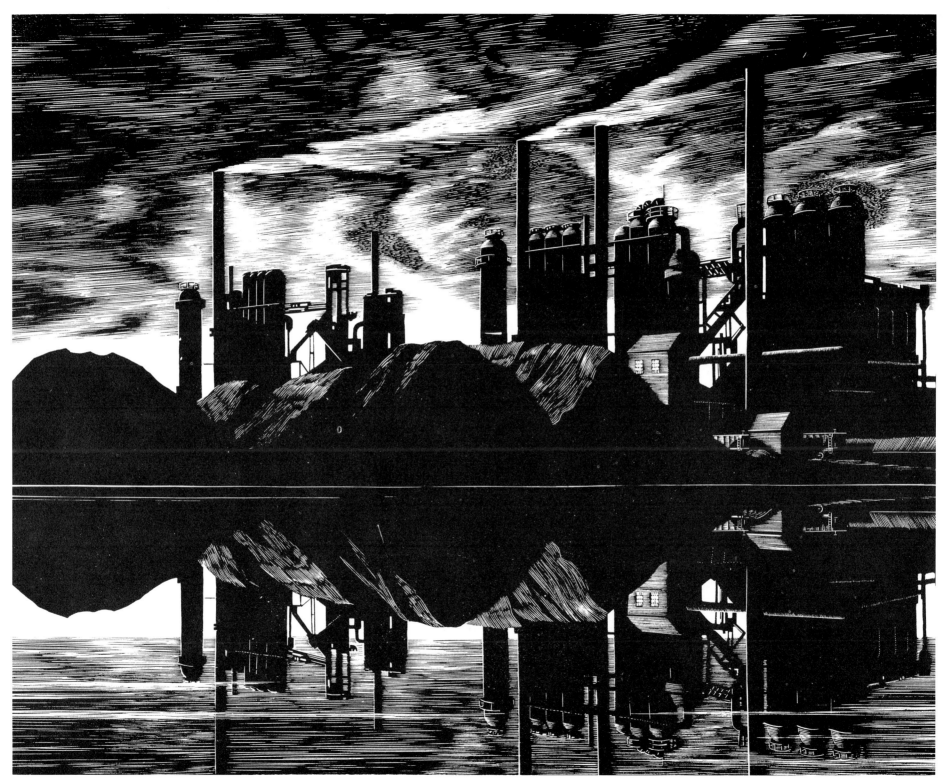

Steel Mill Blast Furnaces
Wood engraving Actual size

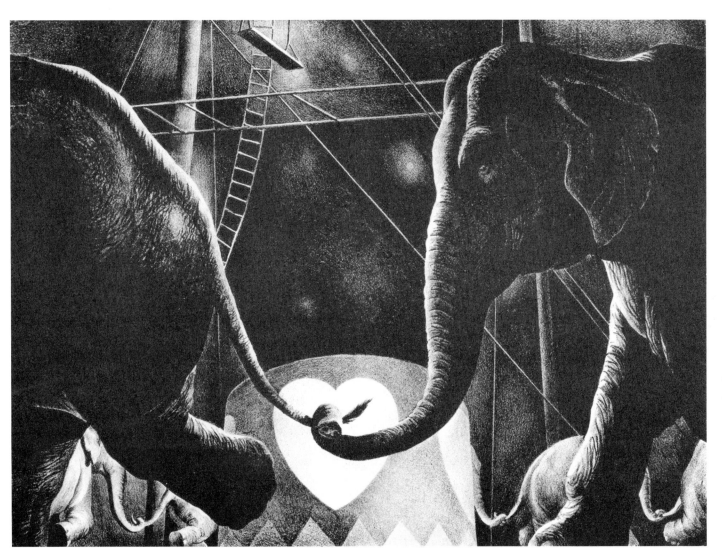

Circus Act
Lithograph on Stone 8 × 10¾ inches

A big circus is such a kaleidoscope of sound, action and color it is difficult to isolate a significant segment for a definitive picture. Amid all the confusion of the three ring excitement this parade of elephants, joined trunk-to-tail, appealed to me and seemed to summarize the whole joyous experience. I tried to help the mood by designing a heart on the stand in the center.

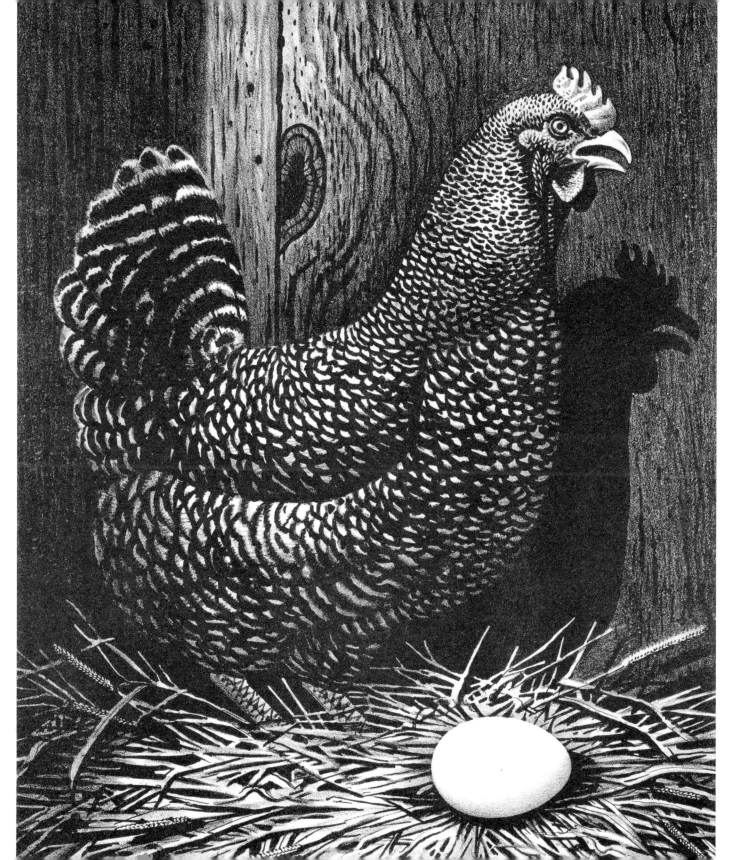

Which Came First?
Lithograph on stone 10 × 12 inches

The perfect natural design is the egg; a shape that has inspired artists, designers, and architects. It is truly one of nature's wonders. Throughout history, the egg has also been a religious symbol—representing a renewal of life every spring. The ancient Persians believed the earth hatched from a giant egg. In the Christian church the Easter egg has become a symbol of the Resurrection. But, the big question still remains, "Which came first—the chicken or the egg?"

69

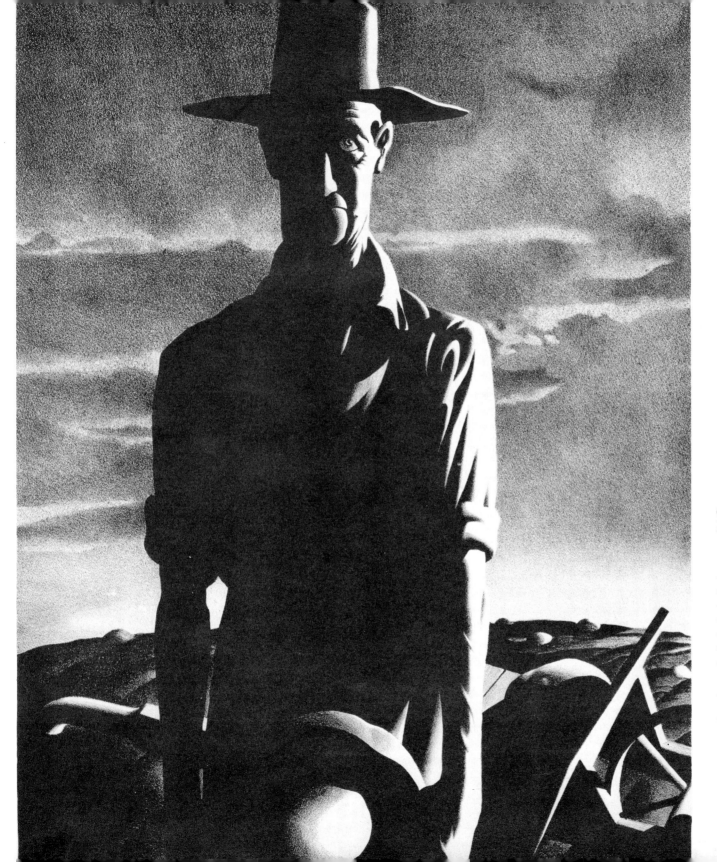

Connecticut Yankee
Lithograph on stone 9½ × 12¾ inches

 Years ago while driving through New England for my first look at this area of America I was impressed with the many stone walls surrounding nearly every field and lining country roads. These walls are all man-made, a laborious process made as a result of clearing tillable land. My concept for this lithograph print grew out of this experience and expresses my admiration for those who performed the back breaking labor clearing the land and building the walls.

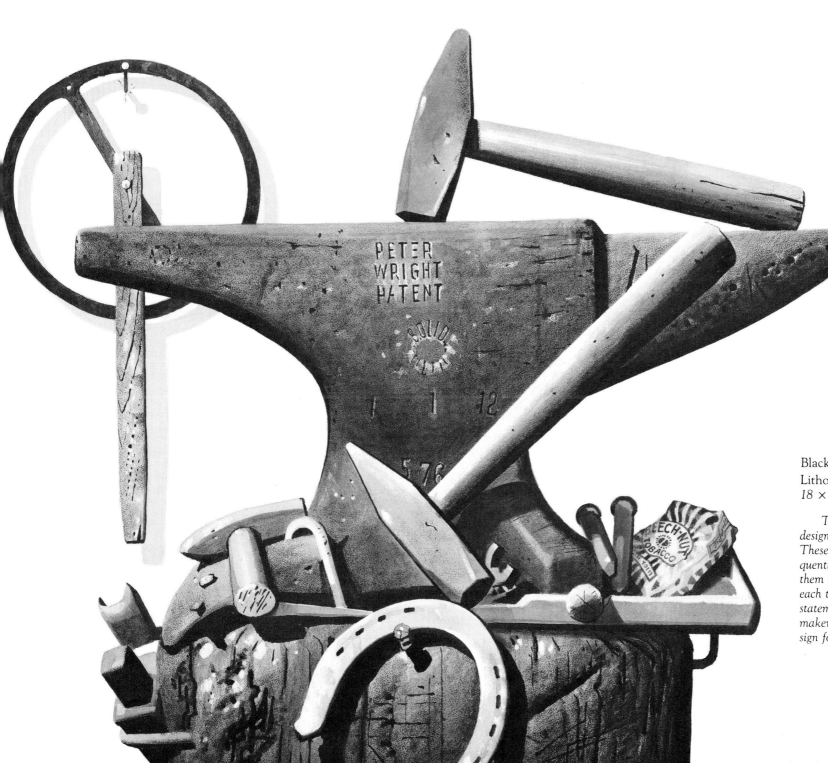

Blacksmith's Tools
Litho crayon on Ross Board
18 × 17 inches

The early American, out of necessity, designed and built many of his own tools. These handcrafted implements speak eloquently of the people who created and used them in their special trades. Inherent in each tool is functional honesty and a clear statement of the pride and ingenuity of its maker. Such tools prove again that good design follows function.

71

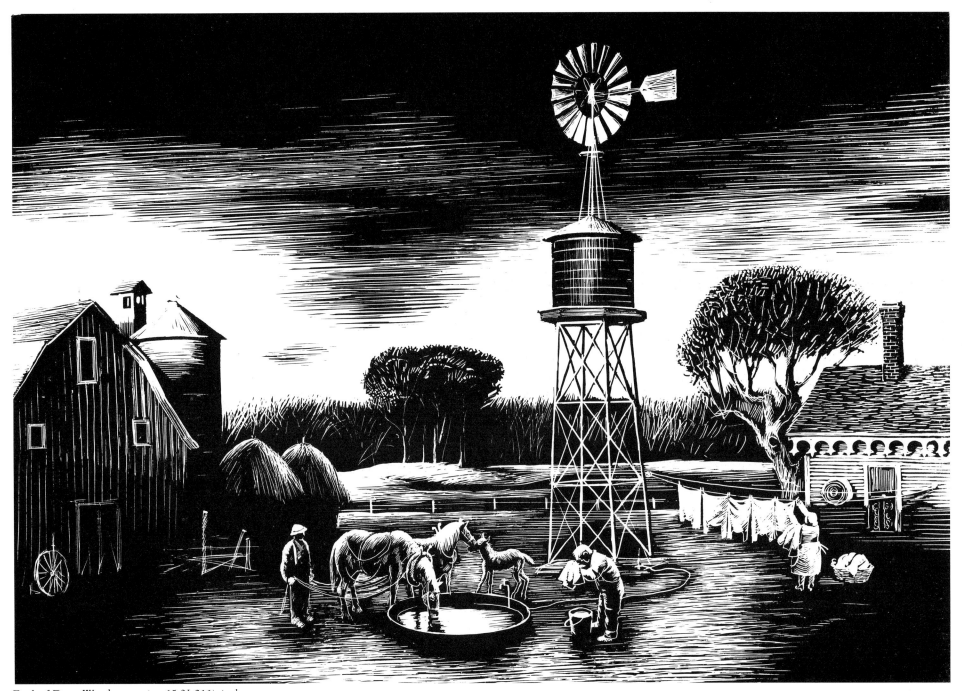

End of Day *Wood engraving 15 X 21¾ inches*

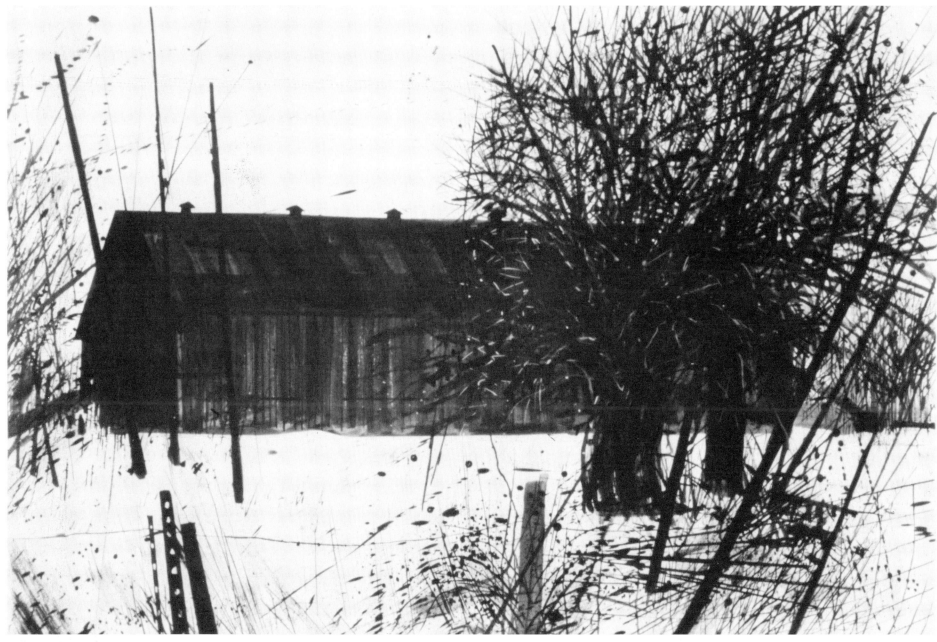

Tobacco Barn in Snow
22 × 35 inches Ink Painting

This Connecticut tobacco barn in a snowy landscape was a deep red with a black roof against a pure blue sky. However the dramatic black configuration and silhouette of the apple trees inspired me to ignore all color. I chose instead to make my statement in pure black using only India Ink and ink washes.

73

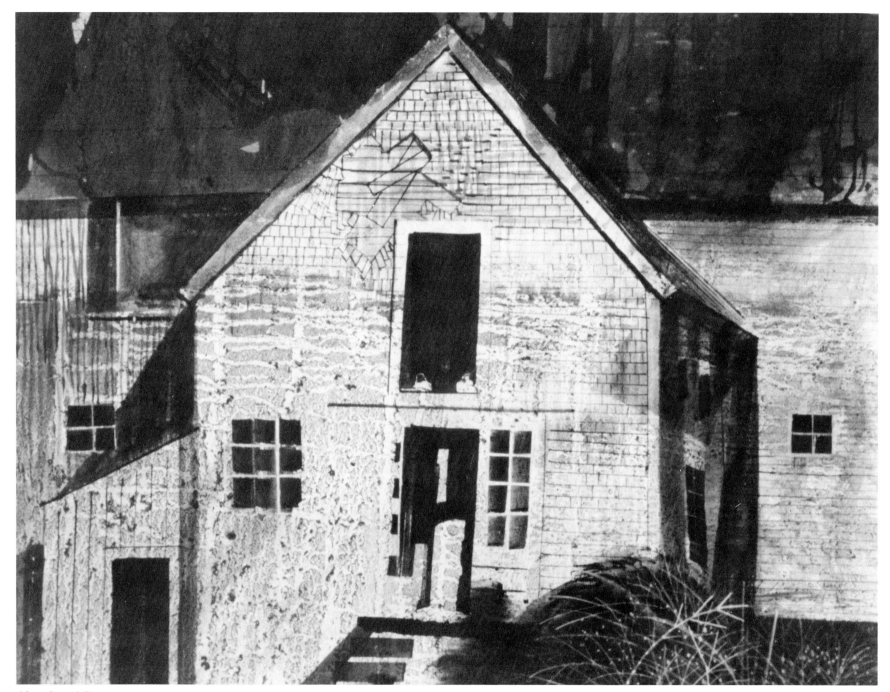

Abandoned Barn
Ink painting 23 × 29 inches

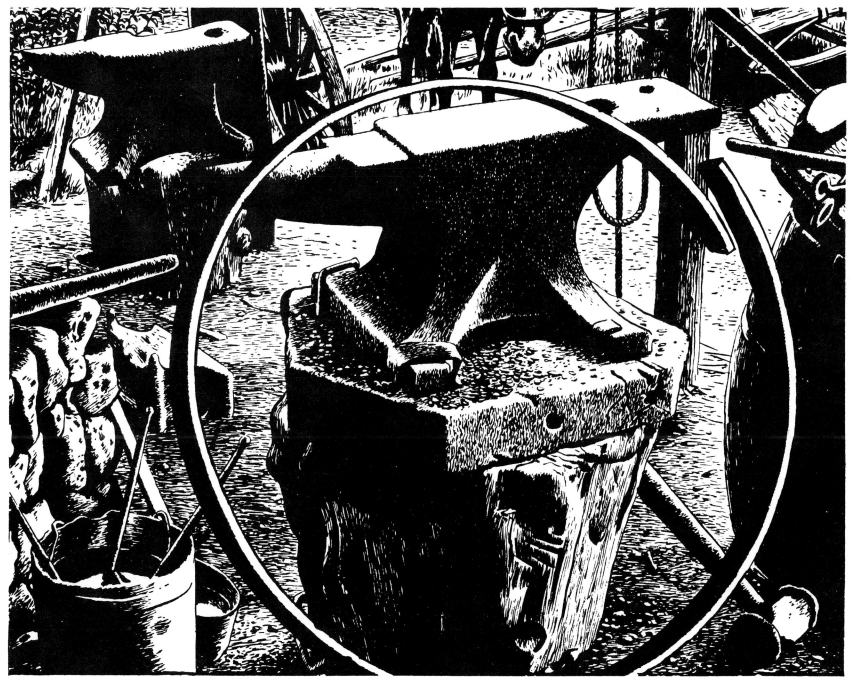

Blacksmith Shop
Pen and Ink 10 × 12 inches

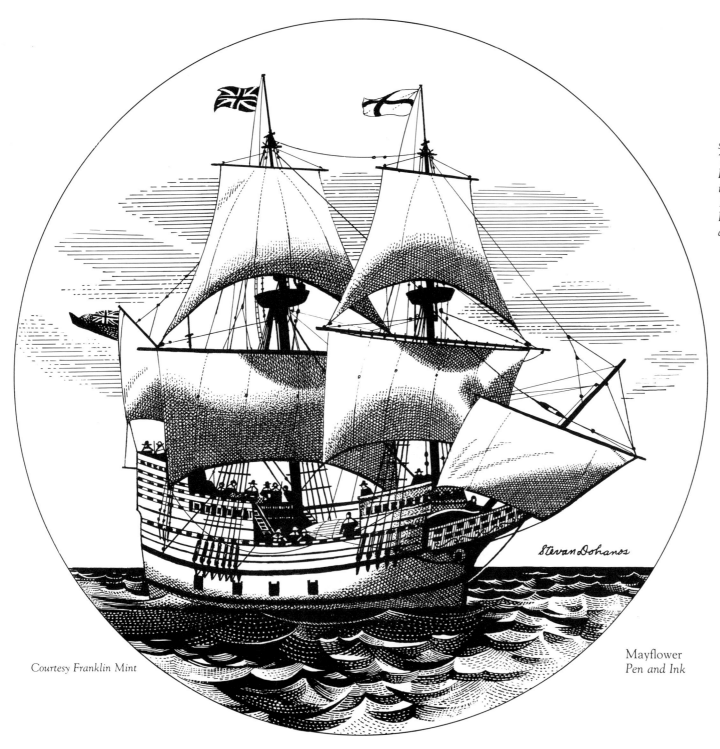

These are designs made for a series of silver plates put out by the Franklin Mint. The plates are referred to as Thanksgiving Day collectible artifacts. The drawings illustrate the arrival of the Mayflower in 1620 and scenes of the daily lives of the Pilgrims. Research for this series was done at Plymouth Plantation in Massachusetts.

Courtesy Franklin Mint

Mayflower
Pen and Ink

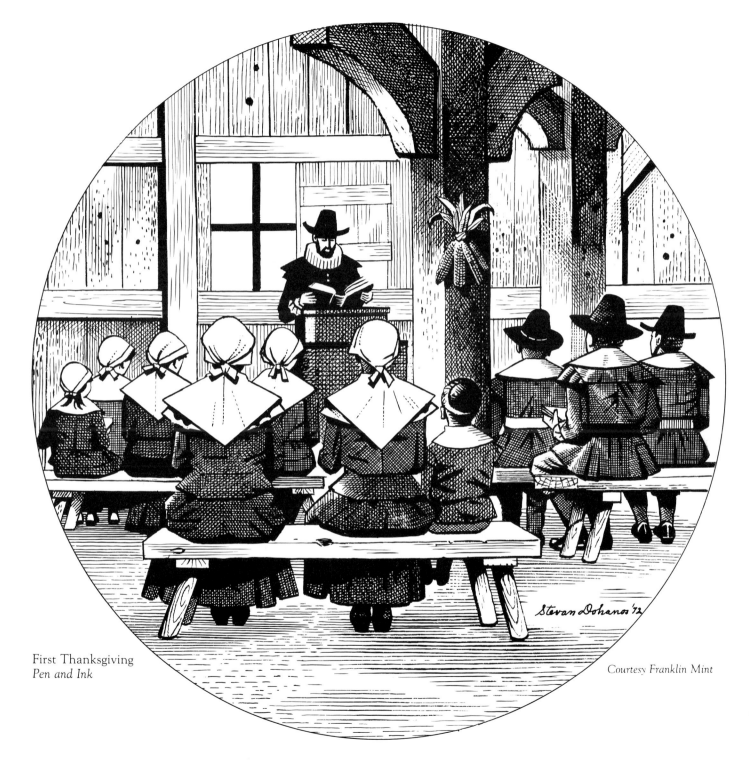

First Thanksgiving
Pen and Ink

Courtesy Franklin Mint

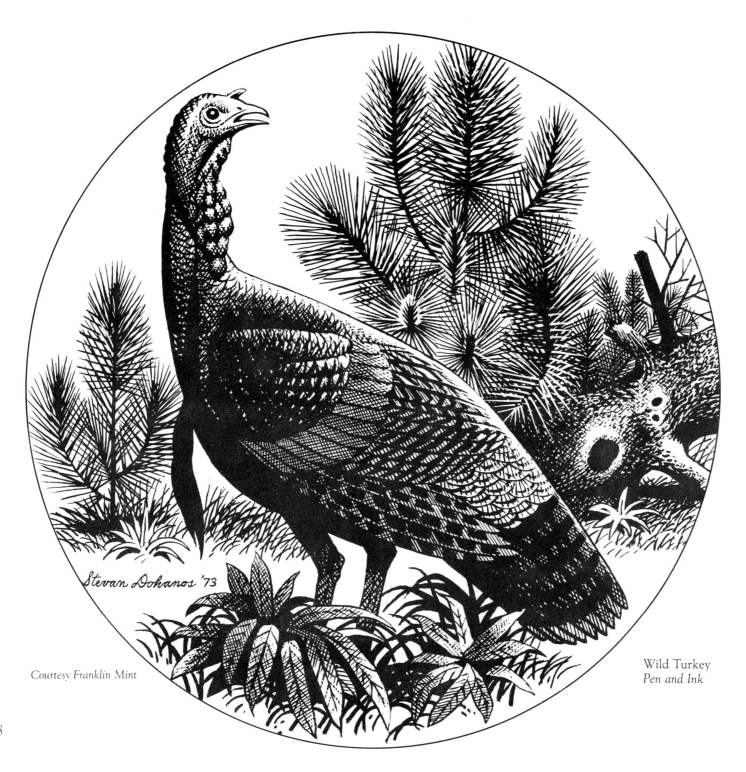

Stevan Dohanos '73

Courtesy Franklin Mint

Wild Turkey
Pen and Ink

Home From the Hunt
Pen and Ink

Stevan Dohanos '72

Courtesy Franklin Mint

calendar art

A good market for the easel painter are calendars distributed or sold at year's end for promotion of every type of business and corporation. Over the years I have produced many paintings for such use. Calendar art offers a wide range of subject matter—landscapes, seascapes, fauna and flora, historical and heritage objects as well as human interest themes. The change of seasons can also be reflected in the monthly pages. The foremost problem for the calendar's sponsor is the concept. For a number of years I have been assigned the job of proposing themes for the annual calendar of The Hartford, a large insurance company. In some of these annually produced calendars I painted all twelve related subjects, in others I was allowed to commission other artists to paint parts of the series. In the following pages several of my paintings are reproduced. Shown at the left is the format of the calendar in which some appeared.

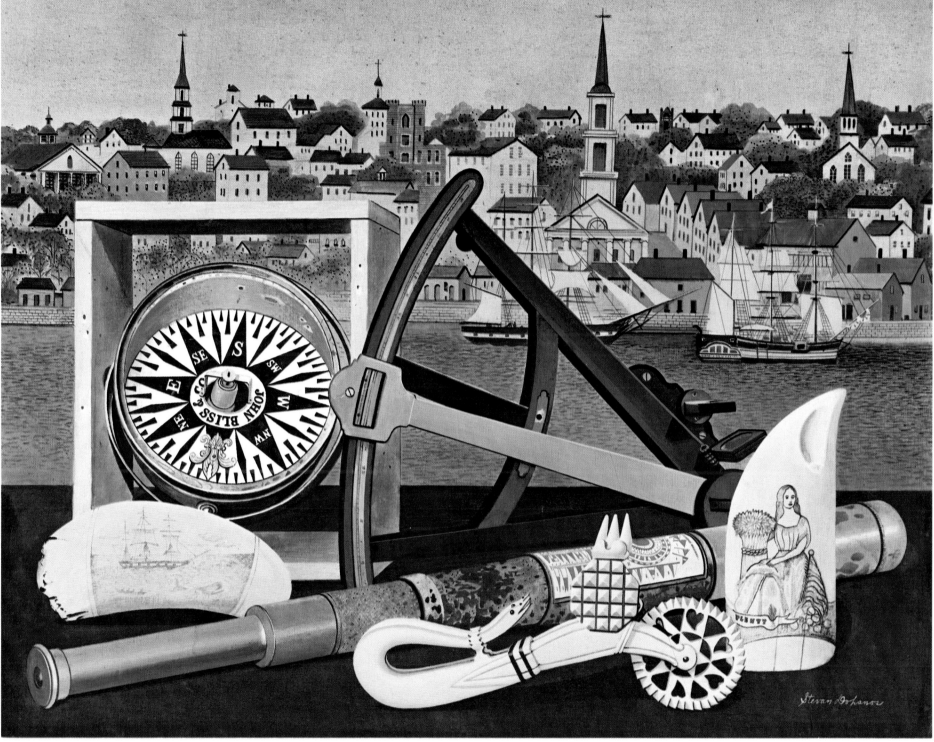

Whaling Days
Tempera on gesso canvas
25 × 31 inches

81

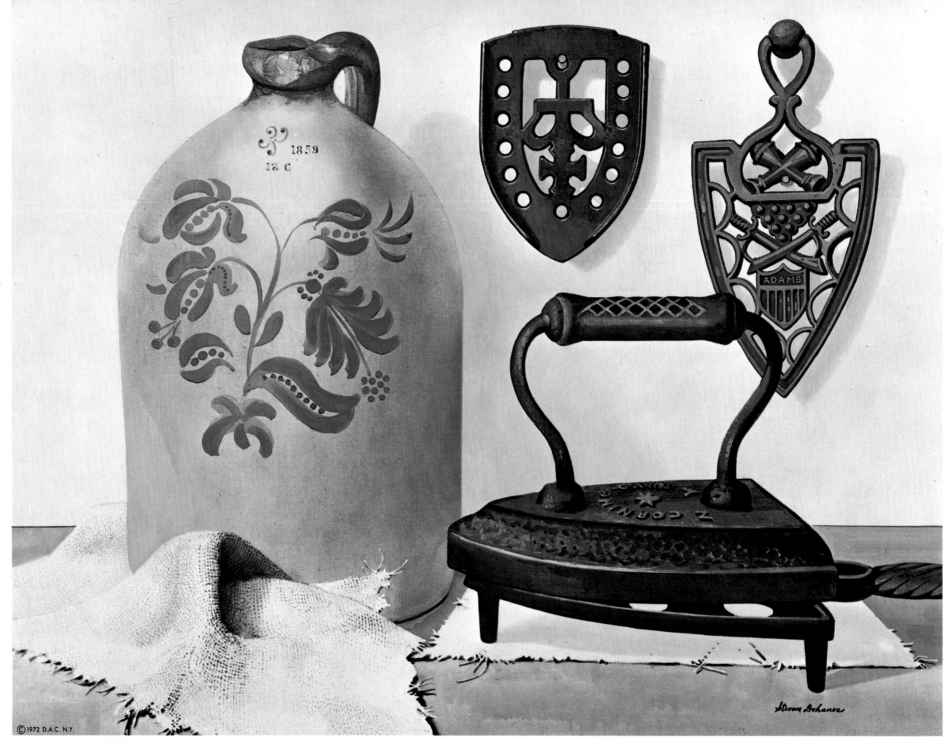

Stoneware Jug and Trivets
Tempera on gesso canvas
25 × 31 inches

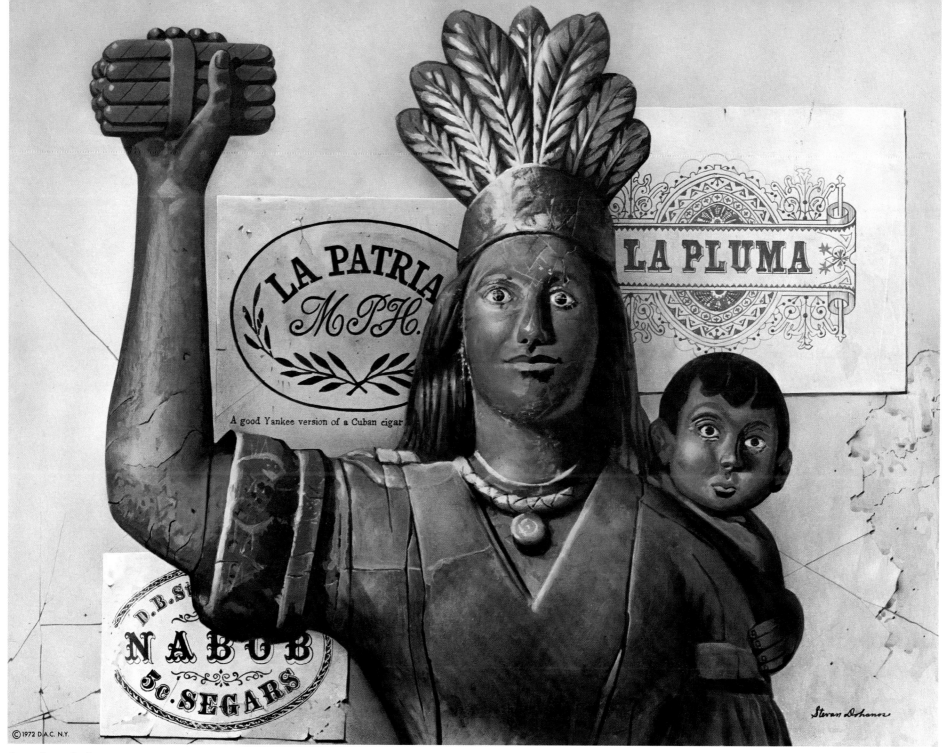

Cigar Store Indian
Tempera on gesso canvas
25 × 31 inches

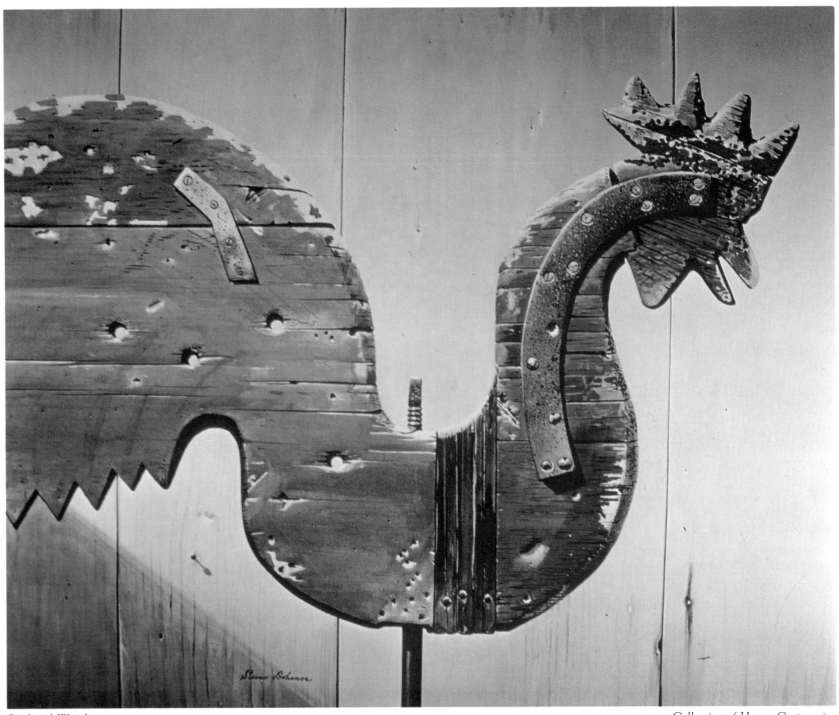

84 Cockerel Weathervane
Tempera on gesso canvas
25 × 31 inches

12 Weathervanes
Tempera on paper
24 × 36 inches
This painting was used as a wrap around
cover for Dunhams of Maine annual catalog.

art in nature

OFFICIAL FIRST DAY COVER

100TH **ANNIVERSARY**

Praying Mantis *Symbol designed for 100th Anniversary Postal Cachet—May 1970*

The artist's greatest source of inspiration almost always stems from nature, the wonders of which can be found from the floor of the oceans to the stars above.

Man's priceless heritage is the eternal truths found in our world with its seasonal cycles, the rebirth of many forms of life which sustain us and offer beauty as well.

The miracles of nature are never ending wonders—a constant inspiration and the basis of all beauty and art. Forms of endless variety, color and splendor are there awaiting the personal interpretation of the artist.

Butterflies and Insects ►
Tempera on gold mat board
12 × 15 inches

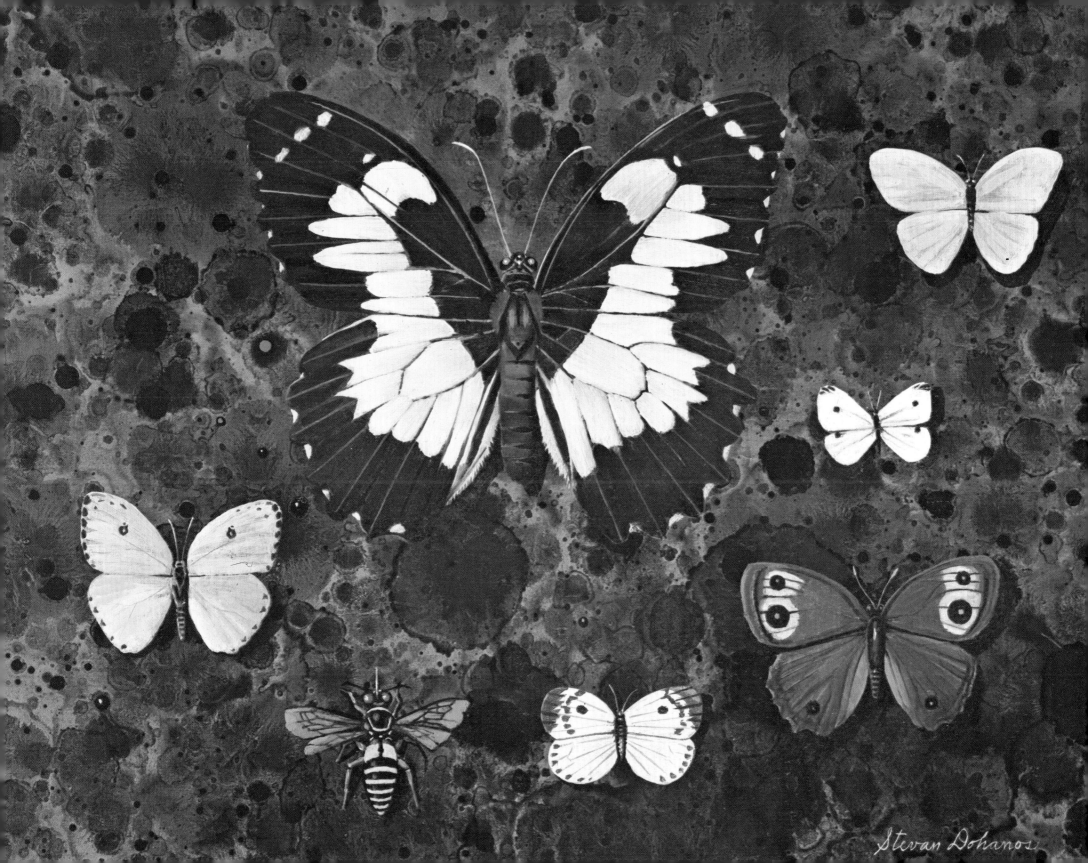

Stevan Dohanos

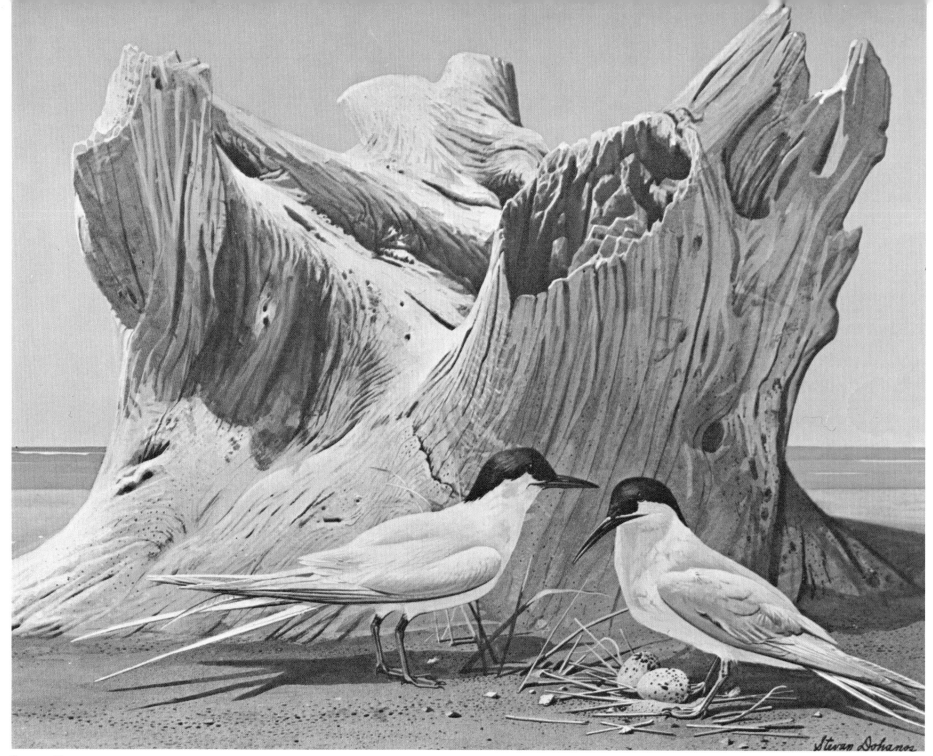

Roseate Terns
Tempera on gesso canvas
25 × 32 inches
Collection of Mr. and Mrs. Charles Wisner

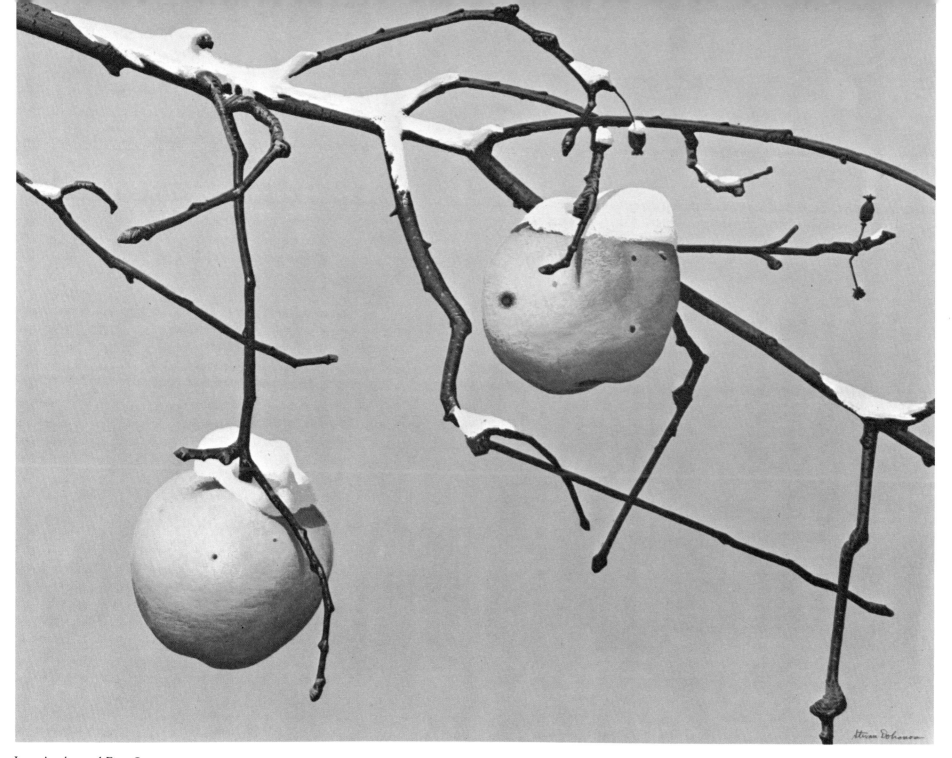

Last Apples and First Snow
Tempera on illustration board
25 × 32 inches
Collection of Mr. and Mrs. Peter Neiman

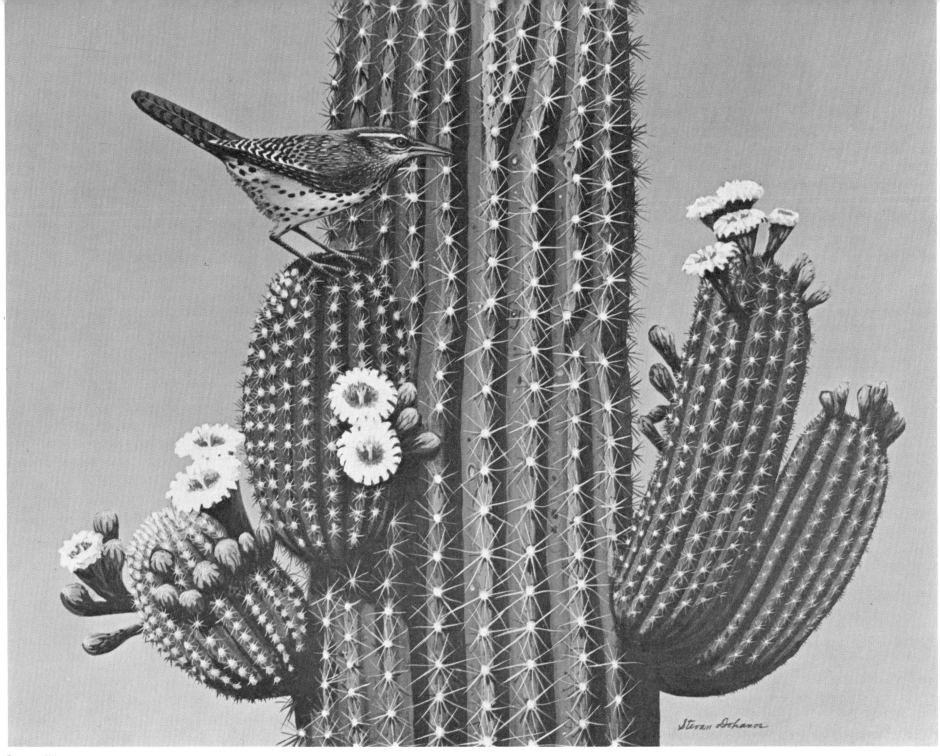

Cactus Wren
Tempera on gesso canvas
25 × 32 inches

Barn Swallows ▶
Tempera on wood panel
24 × 30 inches
Collection of Mr. and Mrs. David Smith

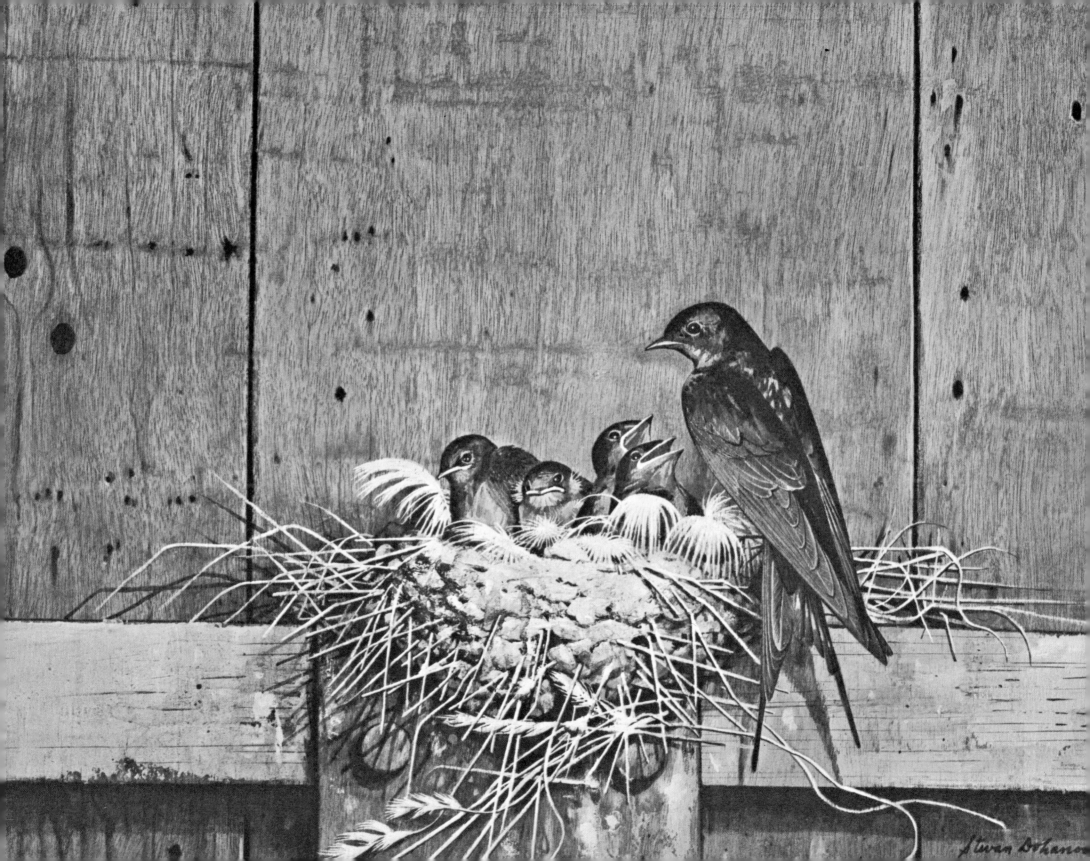

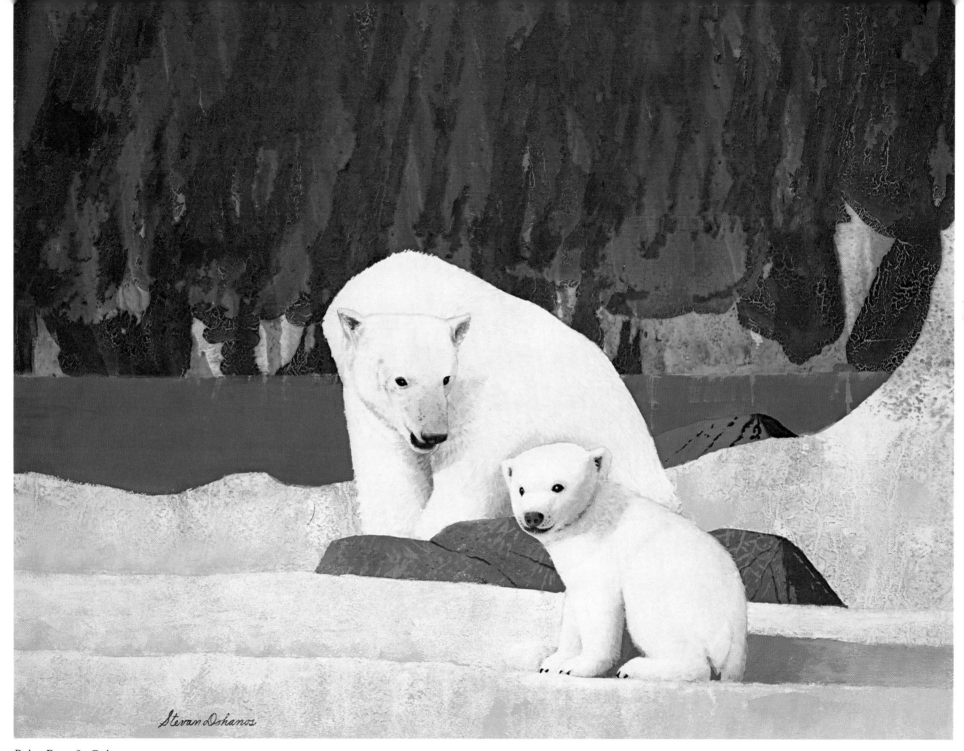

Polar Bear & Cub
Tempera on Multimedia board
20 × 24 inches
Collection of the Hartford

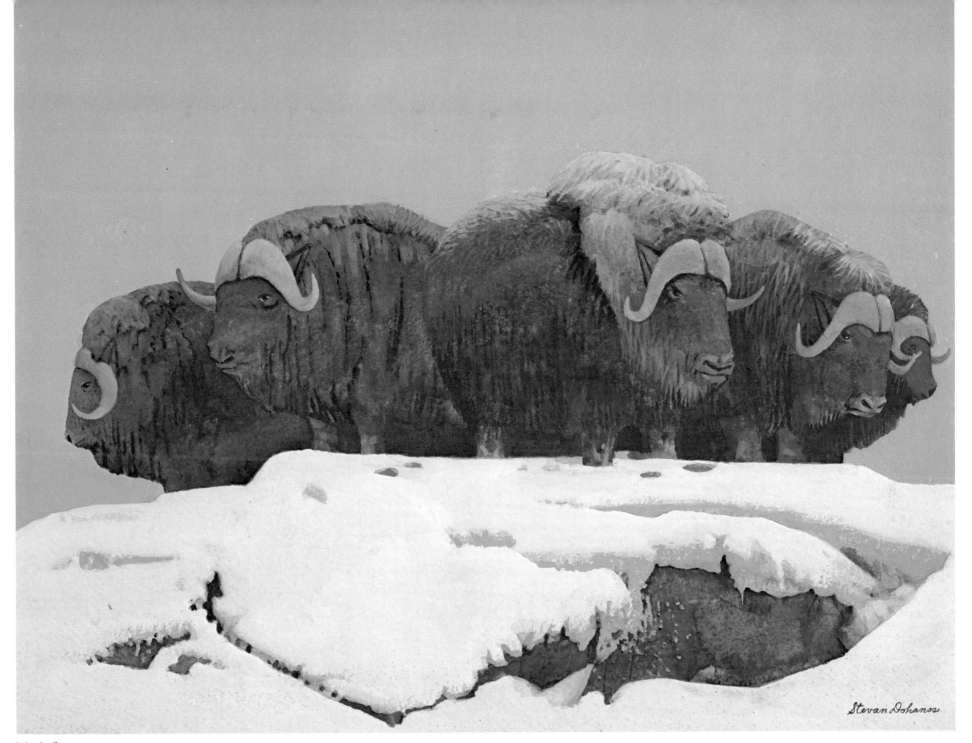

Musk Oxen
Tempera on Multimedia board
20 × 24 inches
Collection of the Hartford

93

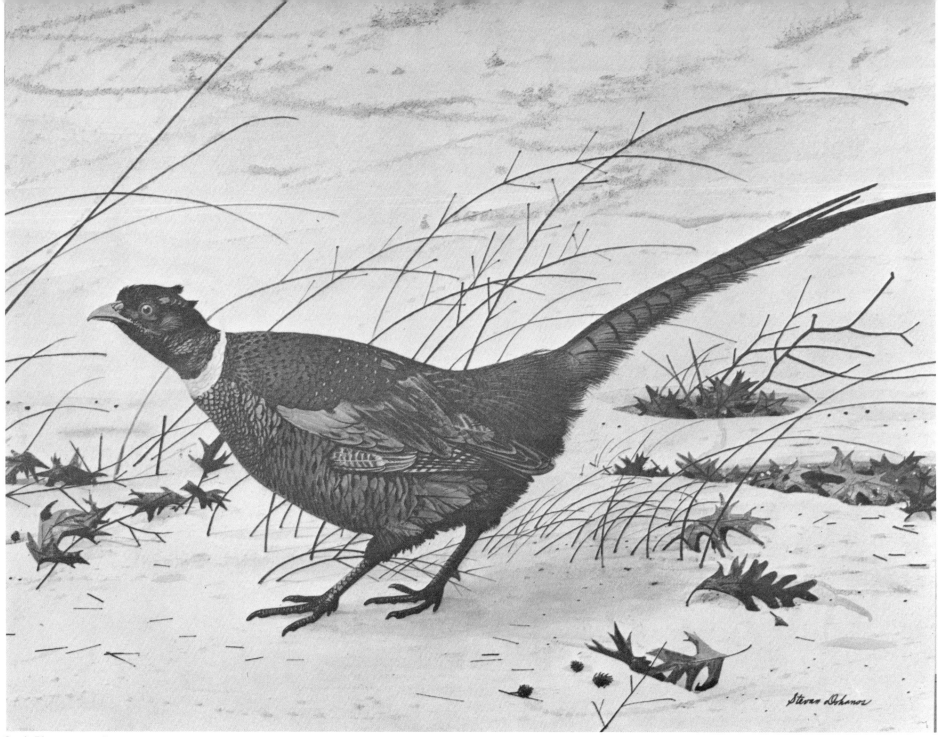

Cock Pheasant in Snow
Tempera on illustration board
24 × 30 inches
Collection of Mr. and Mrs. Charles Arms

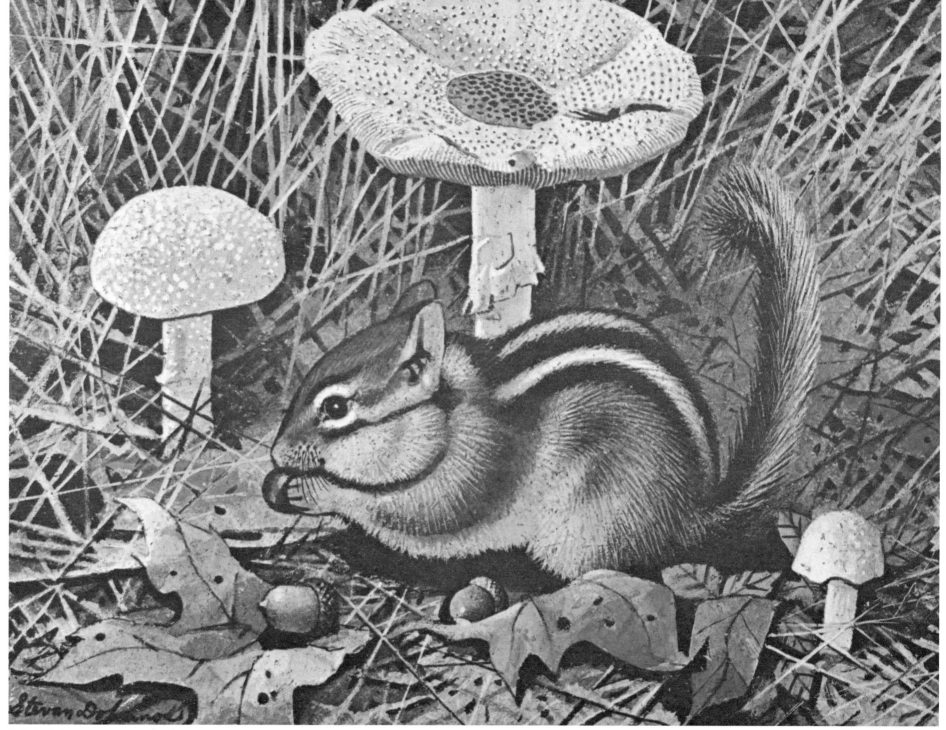

Fall Activity
Tempera on illustration board
8 × 10 inches
Collection of Nature Center, Westport, Connecticut

95

small fry

The next few pages are inspired by personal observation of the activities of youngsters. As a father of three sons, living in an average town and having my working studio at home made it possible for me to sort out the activities of the younger folks that trooped in and out of the house. Their activities at every age had "story value" and appeal. It was never difficult for me to find models when needed to authenticate the doings and demeanor of the younger generation. I spent many pleasurable hours finding the right baby, youngster or teenager as models. This is a good opportunity for me to thank all mothers, teachers and the many young people who cooperated so many times and made it easy for me to depict the world of the "small fry."

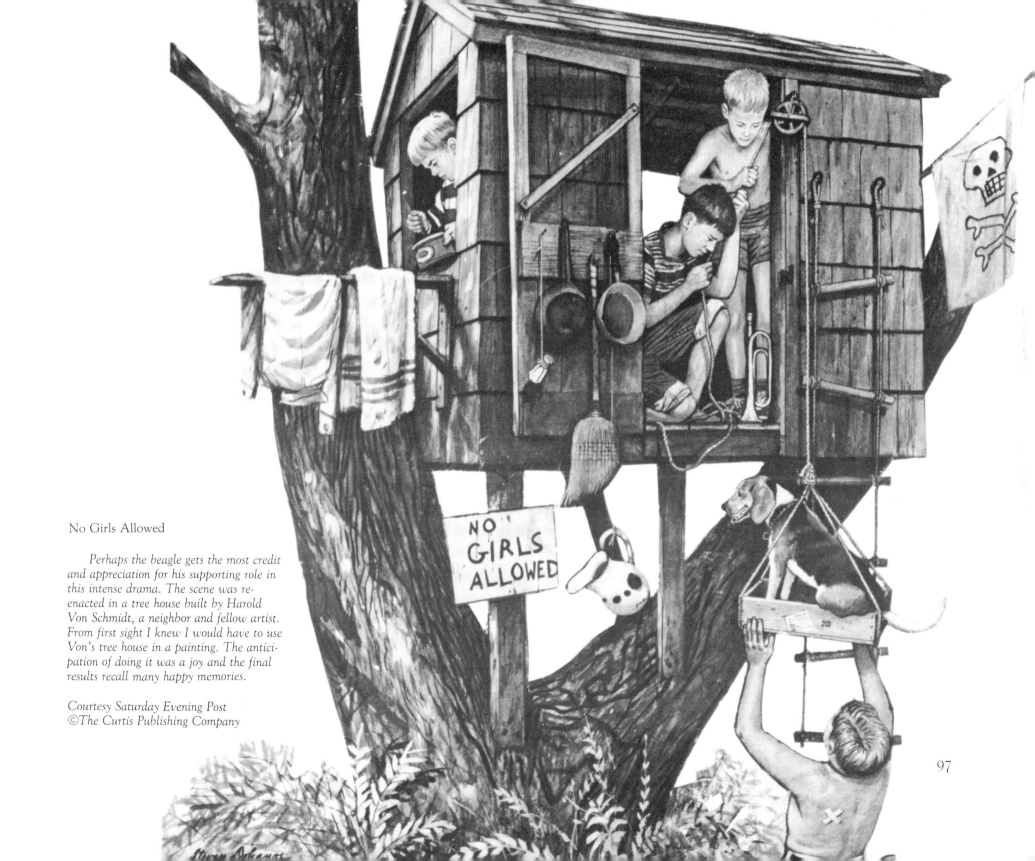

No Girls Allowed

Perhaps the beagle gets the most credit and appreciation for his supporting role in this intense drama. The scene was re-enacted in a tree house built by Harold Von Schmidt, a neighbor and fellow artist. From first sight I knew I would have to use Von's tree house in a painting. The anticipation of doing it was a joy and the final results recall many happy memories.

Courtesy Saturday Evening Post
©The Curtis Publishing Company

97

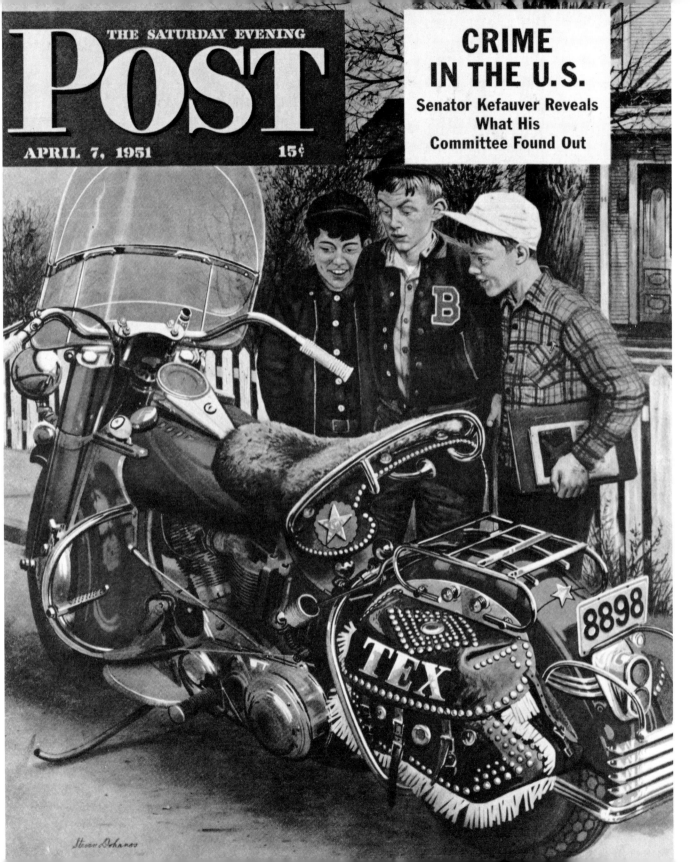

Motorcycle

The Harley-Davidson motorcycle was always a show stopper. Even with today's array of international bikes I think the legendary Harley-Davidson would attract an admiring crowd of school boys—and maybe some of their fathers.

©The Curtis Publishing Company

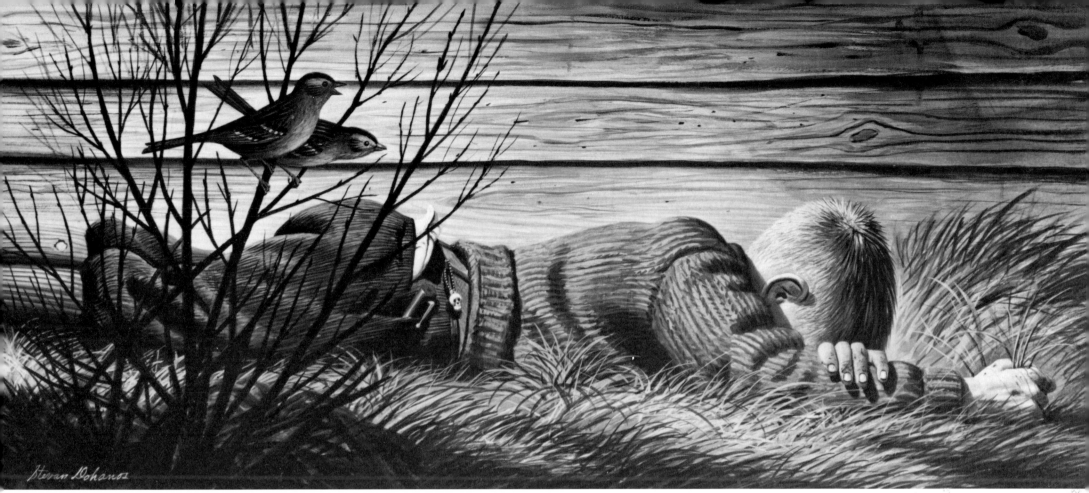

Heartbroken
©*The Curtis Publishing Company*

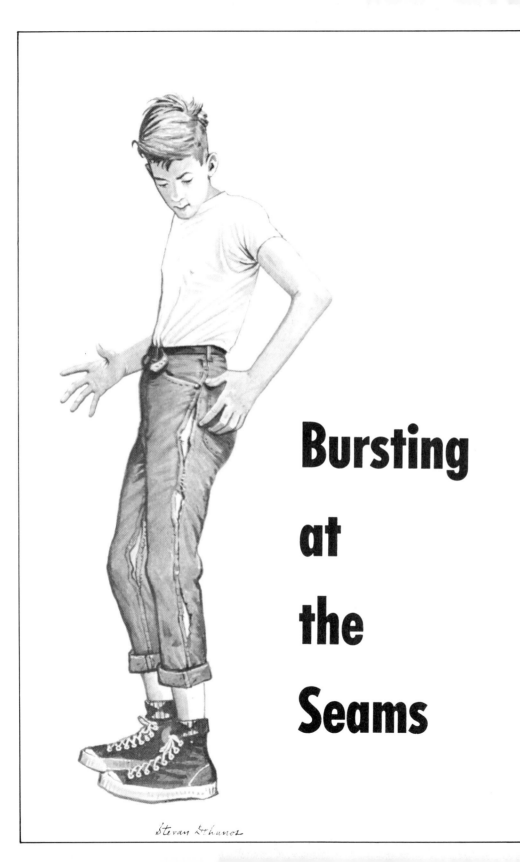

Stevan Dohanos

Bursting at the Seams

YMCA Fund-raising brochure

The artist's creativity can serve many practical functions in the field of communications. The visual approach is essential to the success of almost every project be it a national advertising campaign or a local fund raising appeal. Over the years I have worked with a number of community endeavors contributing my talent as an artist to worthwhile causes. One example is a fund raising drive to enlarge the facilities of our local YMCA.

The committee on which I served wanted to put out a brochure about the project and I was asked to submit some ideas and slogans. The 'outgrown blue jeans' idea was the favored solution. With a few key words and a helpful young model, the promotion problem was easily solved. Happily, the quota was met.

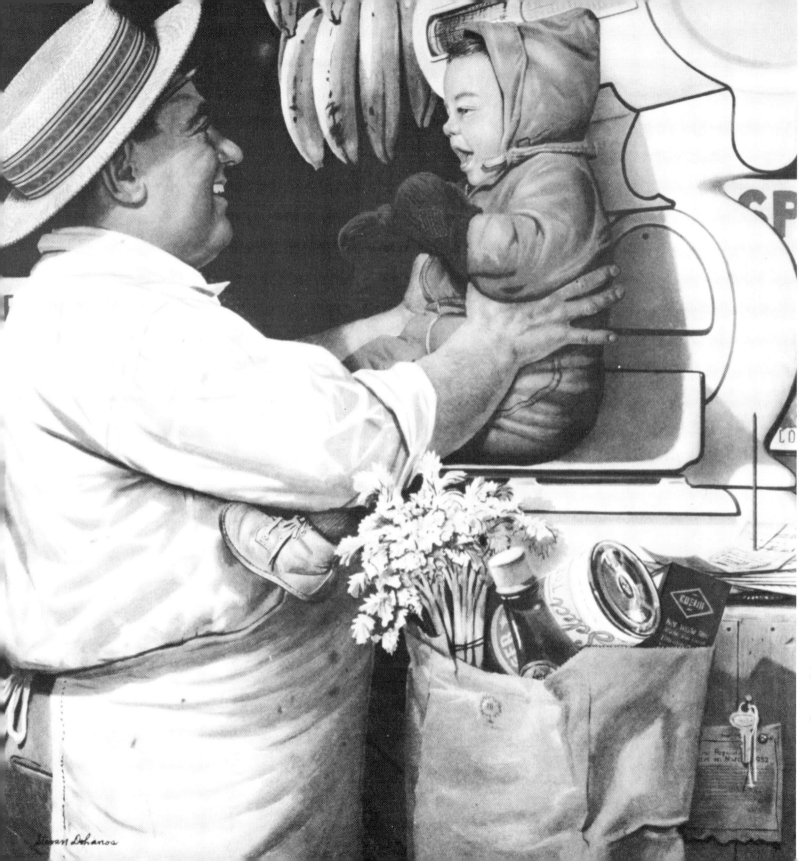

Baby on Butcher Scale

Collection of Mr. and Mrs. Ralph Pisano
©*The Curtis Publishing Company*

101

One Penny Sale

A small country store in my neighbor-hood became the perfect backgound for the big decision of what a penny would buy. This surely dates this cover painting. Penny candy really used to exist.

Collection of Mr. and Mrs. Sherman Small

Sidewalk Superintendents ▶

You are asked to imagine the thoughts of these youngsters as they watch the annual preparation of the tree in front of Town Hall as it is transformed for the magic of Christmas.

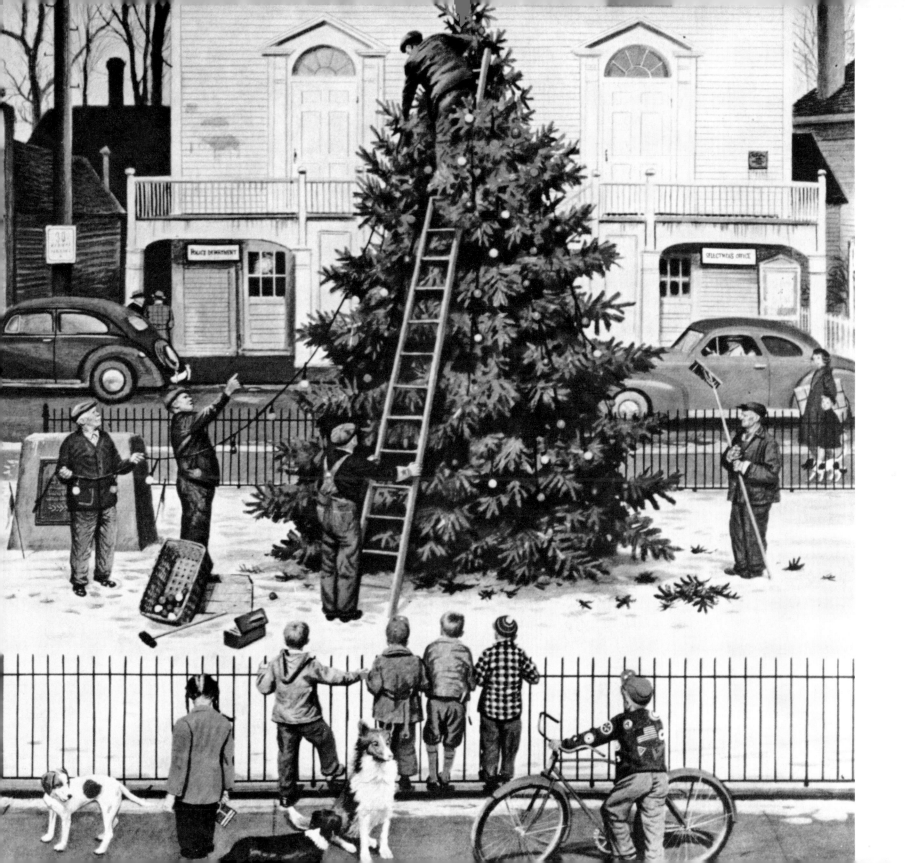

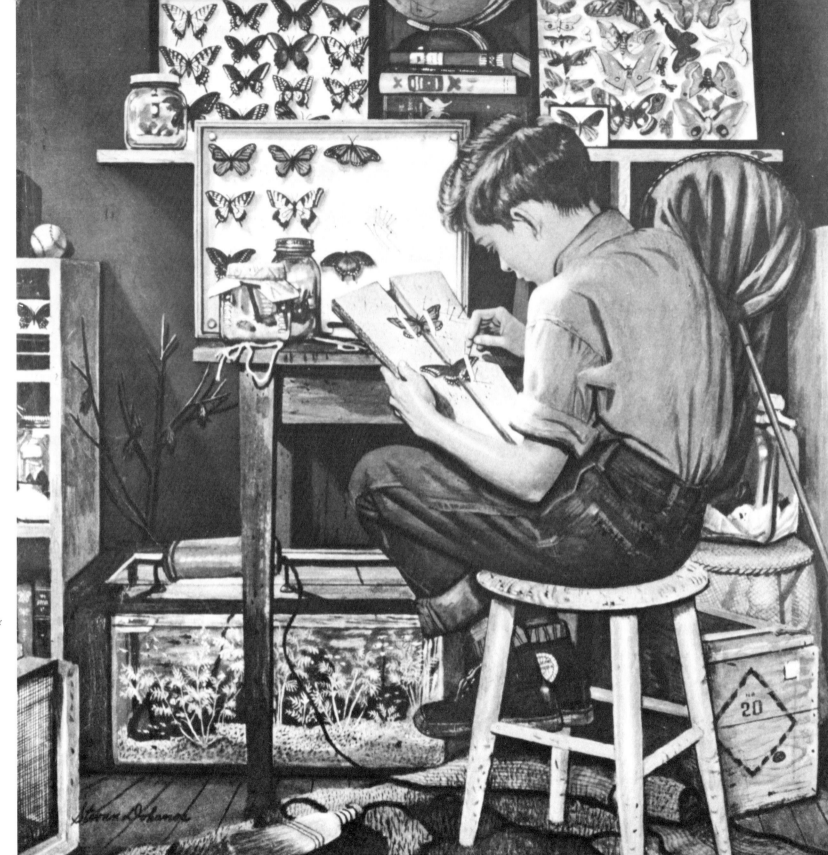

Junior Naturalist

On rare occasions an artist finds the
perfect model in the perfect setting. So it
was when I was taken upstairs to Kit
Dunham's bedroom into a private world
belonging only to him. The one item I had
to change was to make an aquarium out of
the glass box in which Kit had several
handsome snakes. Certain subjects are
taboo in family magazine covers. Snakes
are one.

©The Curtis Publishing Company

104

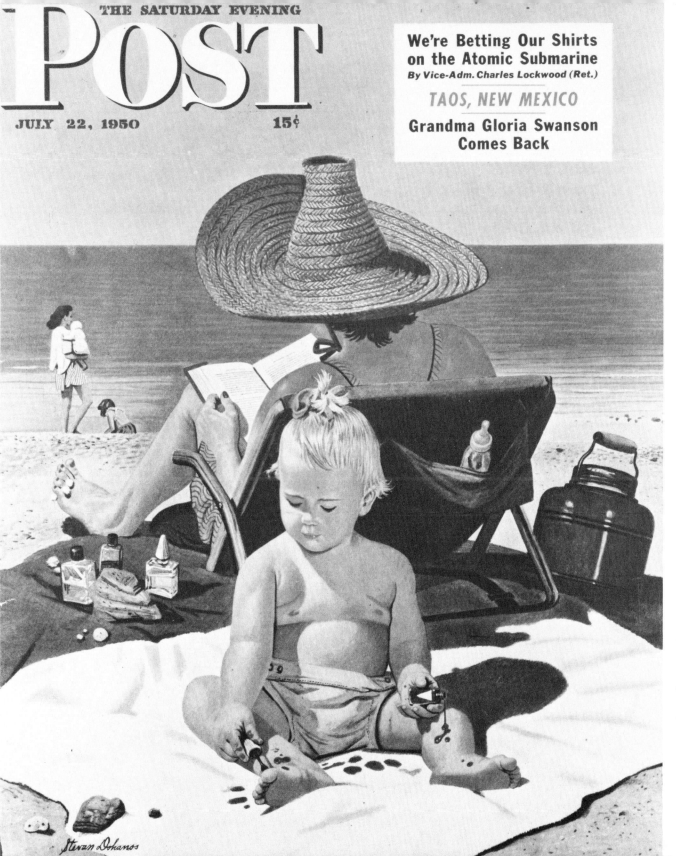

Early Learner

Mother is in for a surprise and will be more careful the next time to keep the nail polish in a safer place. This cover painting developed into a good summertime idea. Because artists work months ahead of publication, the mother and child posed on the beach for me on a frosty November day.

Collection of Mr. and Mrs. Charles Wisner
©The Curtis Publishing Company

fiction illustration

Chains of Fear

This fiction illustration is one of several which appeared in the Saturday Evening Post. The story ran as a serial. The preliminary research on Russian uniforms, styling of accurate furnishing and environment was most important. I could not go to Moscow to do this, but found helpful material at New York City photo archives of news agencies and library resources.

◄Man Lost *by E.C. Scoggins*

Man Lost *by E.C. Scoggins*

My experience painting the semi tropical fauna and flora of the Virgin Islands led me by gradual degrees to advertising illustration as well as fiction illustration commissions for the national magazines. This illustration, one of several, for a seven part serial appeared in the Saturday Evening Post. All of the story action in this adventure happened in the Matto Grasso, a place I had never visited, but through careful research and visits to the Museum of National History in New York City, I quickly became an expert on this inaccessible place. For the painting I posed a black model wearing a rented costumer's wig. I carved the throwing device used by the native after an original in the museum.

©The Curtis Publishing Company

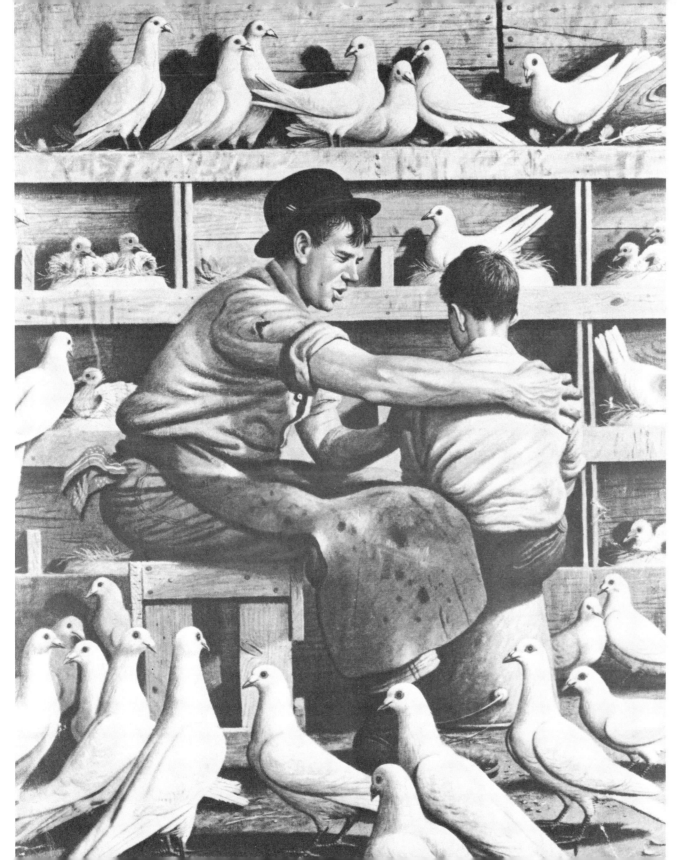

Heart to Heart Talk in Pigeon Loft

This is a story illustration that appeared in the Saturday Evening Post. A blacksmith attempts to reassure a young boy having a problem. The action takes place in a dove cote above the blacksmith shop.

©The Curtis Publishing Company

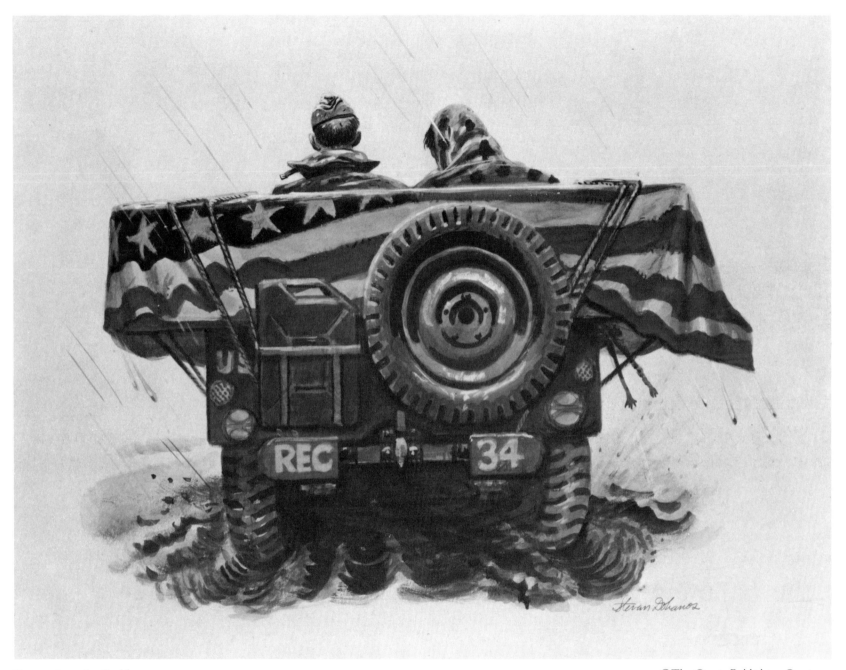

Evacuation of a Buddy

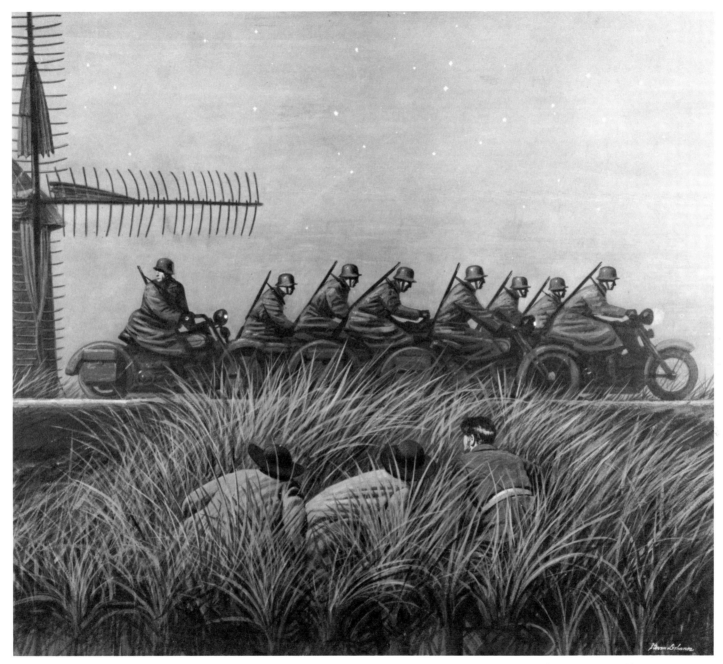

Nazi Motorcycle Patrol *Illustration for Assignment in Brittany*

©*The Curtis Publishing Company*

still life painting

For centuries artists have found pleasure and inspiration in painting foods and common objects familiar to all. Hundreds of still life paintings have become treasured masterpieces gracing the walls of homes and museums. Still life painting evolved as a serious and independent art form some two thousand years ago when it became the principle theme of a painting separate from the human figure. Still life painting can be a highly expressive and satisfying art form.

Now, as in the past, favorite themes have been fruits, flowers and food. The seeking eye of the artist has found additional inspiration in the unusual shape, color and texture of numerous objects used in our daily lives.

Long before machine mass-produced products such as we know today, man designed and built by hand his own working tools, including kitchen utensils and toys for children. Such craftsmen often did not realize the functional objects they created were things of beauty in their own right and add to our cultural heritage.

Material possessions, used or new, tell interesting stories of the life of the times. Such objects can spark the imagination of the artist.

New surfaces as well as the patina of old objects command attention. The still life object communicates out of the stillness of the painting. With the exception of perishable foods and flowers most still life arrangements of inanimate objects quietly await the convenience of the artist, a welcome relief from having to capture the fast changing light and moods of nature encountered by the landscape painter. Still life painting offers an eclectic opportunity for the designer. Such wide choices are available to build into pleasing and exciting compositions.

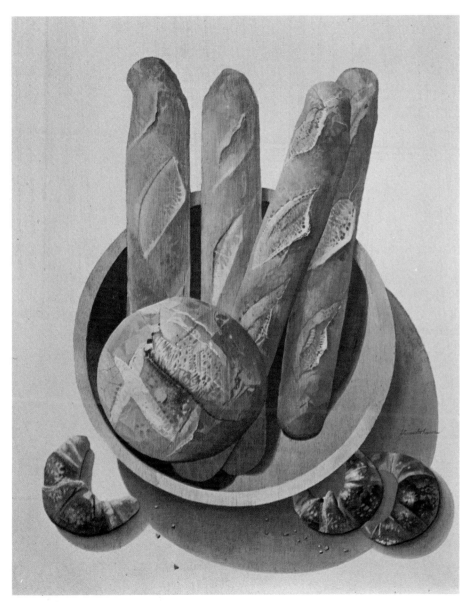

Still Life of Bread and Croissants

Not long ago an authentic French bakery opened in our neighborhood. The delicious breads and fragrant smells of the shop made me an almost daily customer. Besides the taste and smell of the freshly baked goods the subject intrigues me because of the variety of shapes, color and textures the products achieve.

I have painted loaves of bread many times in many compositions. It seems proper and inevitable that breads and croissants become the subject of a still life painting for this book.

For this painting clear plywood was used as a ground instead of canvas. A close look will show a few sections of the wooden bowl utilize some of the beautiful color and texture of the plywood in the finished picture. This was done life size to help carry through the believability I wanted to achieve.

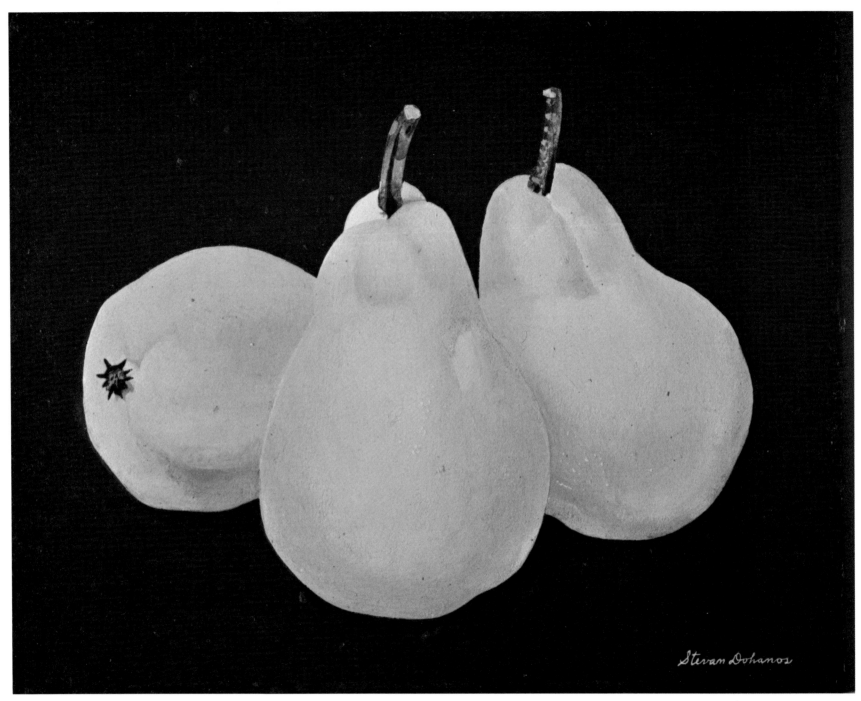

Three Pears

7½ × 10 inches

The Missus Goes Shopping
22 × 26 inches

115

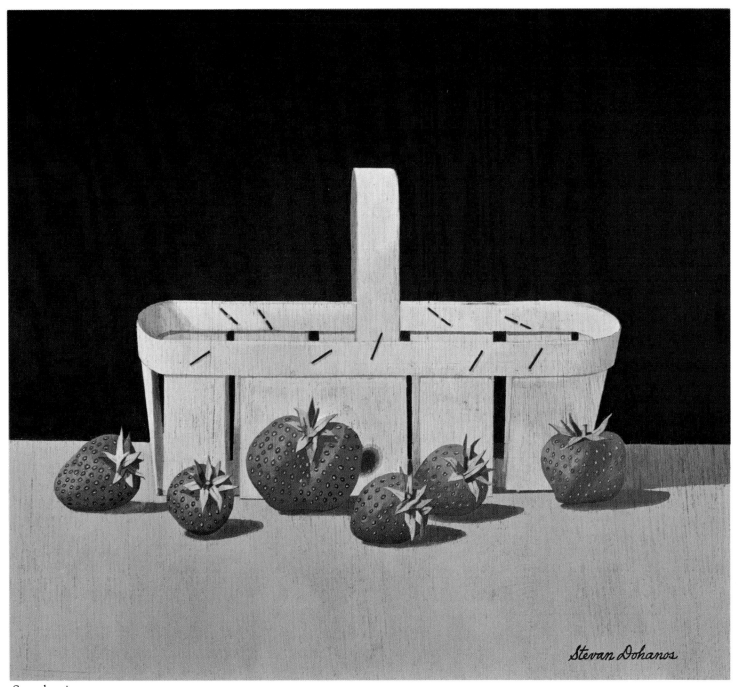

Strawberries
20 × 24 inches
Tempera on wood

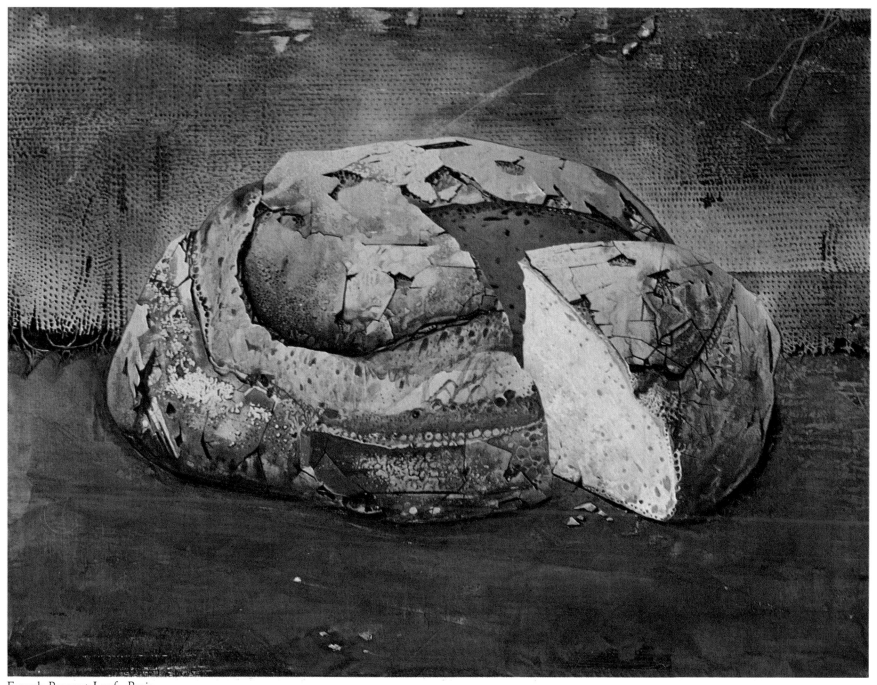

French Peasant Loaf—Paris
18 × 25 inches
Collection of Mr. and Mrs. Sherman Small

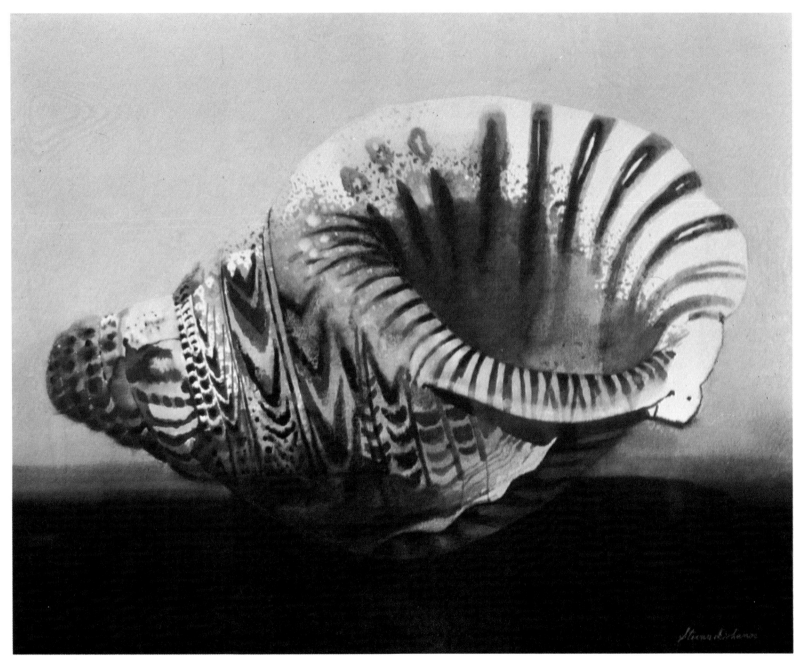

Maui Conch
16 × 20 inches
Collection of Mr. Robert Kelsey

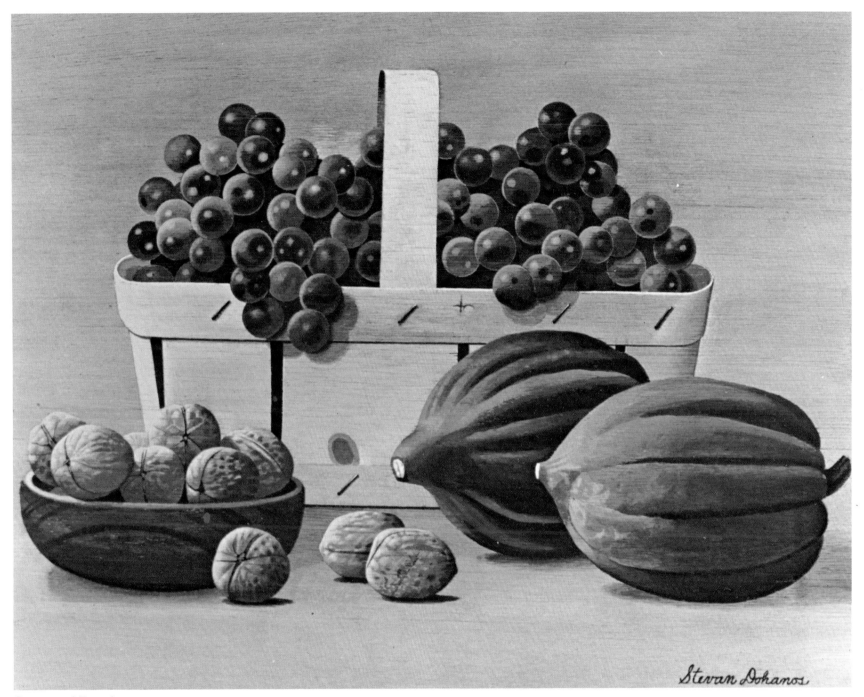

Grapes and Friends
24 × 30 inches

easel painting

As an artist I have spent most of my professional life satisfying specific needs of clients. This is both a responsibility and a pleasure. However, there is no greater reward for me than going out into the countryside and painting only what appeals to *me*. You can call it Sunday painting or, perhaps, a postman's holiday. My easel painting began just that way—a desire to paint and fulfill my own artistic needs. I go on such excursions whenever possible. My outdoor sketching gear always stands ready for use.

What I like, on such outings, is the element of surprise and discovery that sometimes produces the unexpected painting when you start with no preconceived plan. In scouting around for subject matter afoot or by car, the artist is the "hunter" and bringing home a satisfying painting affords me much pleasure.

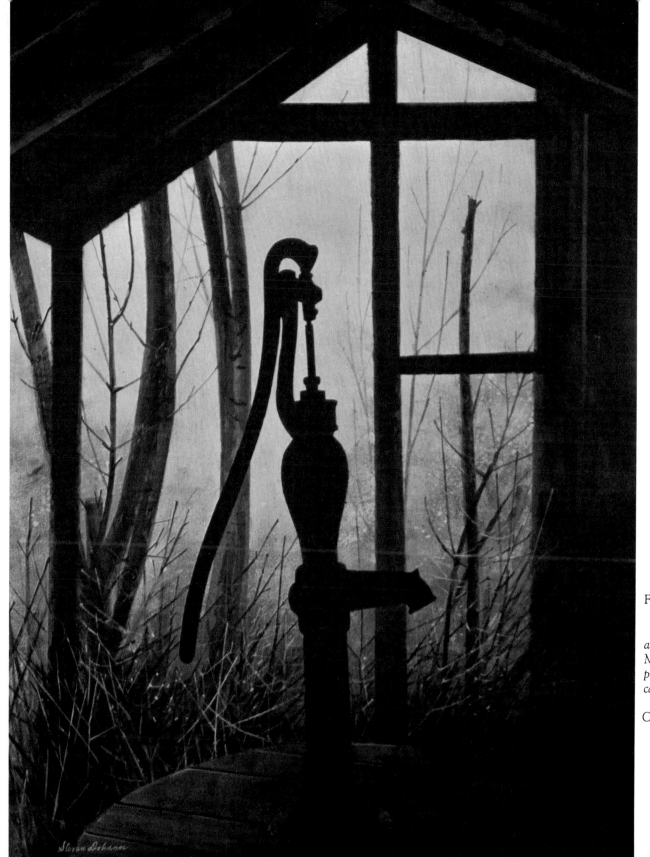

Farm Pump

About a mile from my studio I came across a small, neglected farm building. Much to my surprise it housed an old well pump. An authentic piece of rural Americana was waiting patiently to be painted.

Collection of Mr. and Mrs. Sherman Small

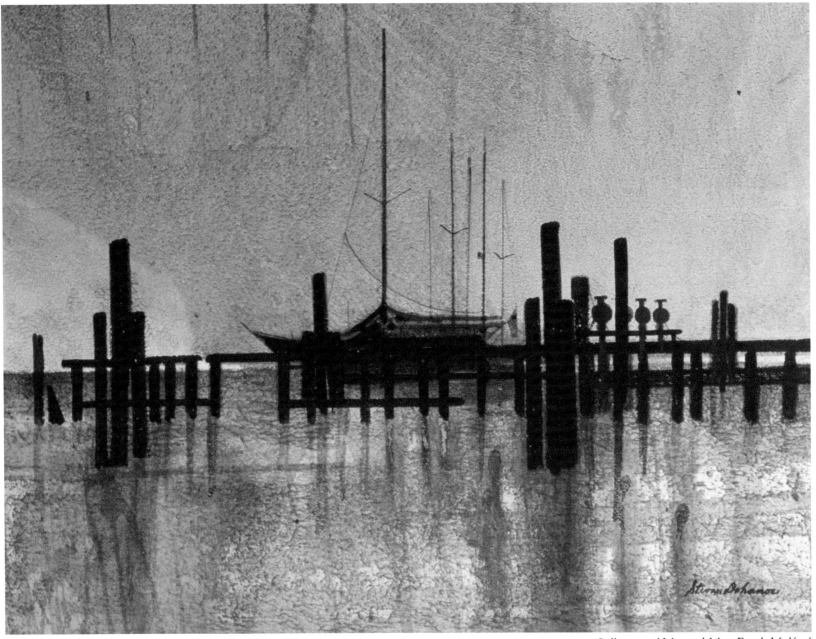

Unused Dock

Collection of Mr. and Mrs. Frank Mulford

House on Gorham Island
30 × 40 inches

the artist travels

I have painted subject matter in many parts of America and many places around the world. Some of these trips were made for specific reasons such as the picture on the opposite page. This painting was done as an official assignment for the United States Air Force. After visiting several air force bases I selected this scene at Johnson Air Force Base in Japan.

The title of the painting is "Cookout in Ichiban" and shows air force servicemen and their families enjoying a barbecue "American style" at homes where they were billeted near the air field. I produced this large painting later in my Westport studio, using my sketches and notations. Photographs made for me by an accommodating air force photographer were also extremely helpful. On the following page are pictorial reports of other far off places.

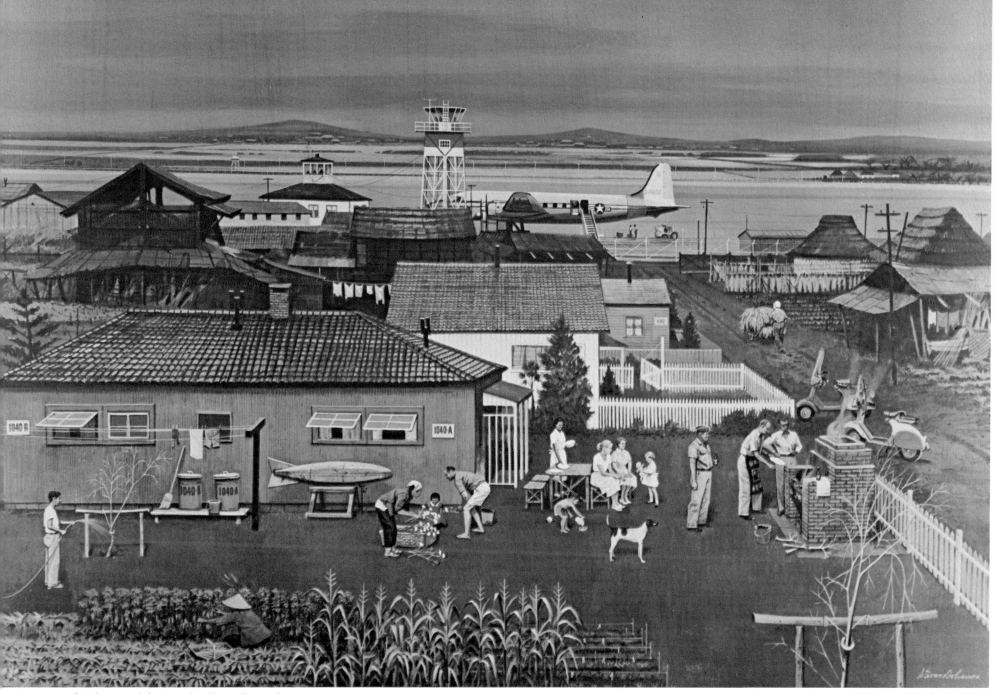

Cookout at Johnson Air Force Base—Japan
48 × 54 inches

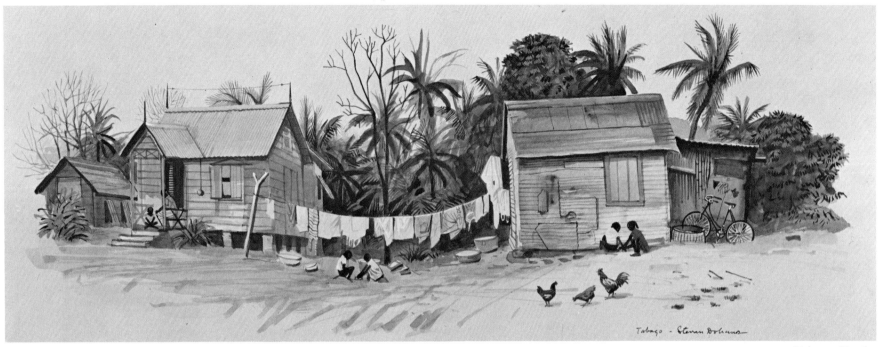

Tobago Shacks
8 × 16 inches

*Two shacks held together by a line of colorful
laundry attracted me while on a sketching prowl on the
island of Tabago. I completed the painting in one sitting
and was grateful for the shade of a palm tree, as well
as the children and chickens arranging themselves in the
proper places. I have stopped carrying a camera to
record scenes such as this. From long experience I know
I seldom get around to doing the after the fact painting.
I've learned when acting as my own client I had better
paint on the spot while the spirit moves me.*

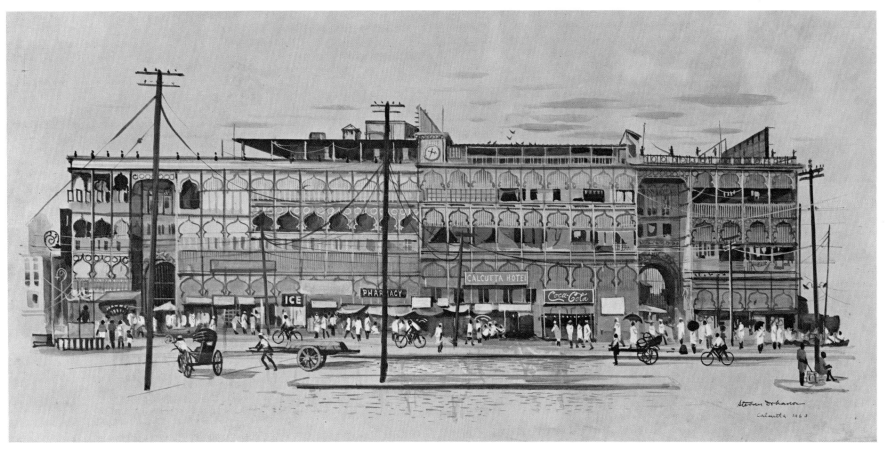

Calcutta Business Block
12 × 22 inches

When I came upon this structure I could not believe
what I saw and I determined it had to be painted to be
believed. I excused my taxi driver and asked him to pick
me up four hours later which he did. In that period I
tried to capture the amazing details, color combinations
and the activity of the street. Unfortunately the best
vantage point to accomplish this was a section of
sidewalk and curbstone on the opposite side of the
street. I soon became surrounded with crowds of pedes-
trians, all anxious to see the painting. Luckily an officer
helped control the immediate sidewalk traffic jam I had
created and stood by until I had finished the painting.

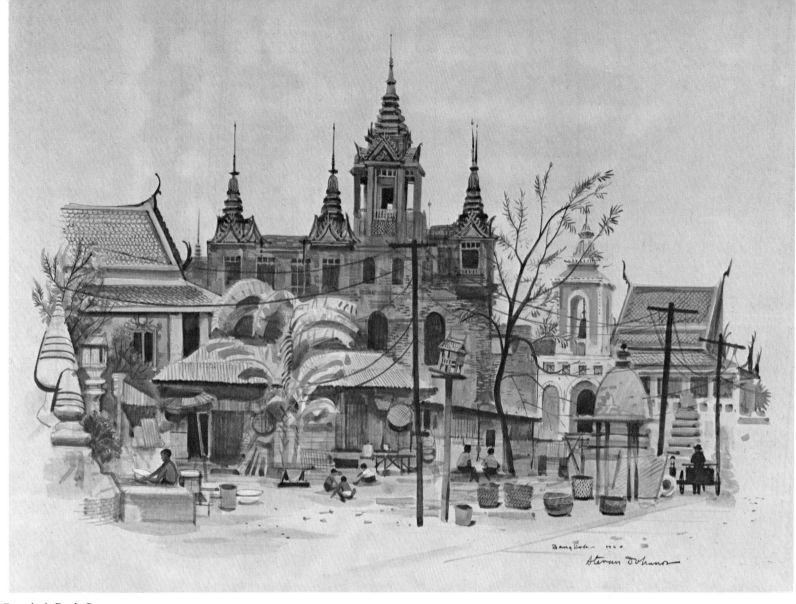

Bangkok Back Street
15 × 22 inches

While my eyes feasted on the overwhelming grandeur and opulence of the golden temples and shrines in Bangkok it was an overdose for me. By diligent leg work I found a section of the city that was off the tourist beat. Here is the watercolor I painted that day. As I was finishing it the coal man with his cart appeared, adding a "behind the scenes" piece of realism and serving as a balancing element to the composition. His face, clothing and coal cart were solid black.